GHOSTS OF
NEW HAMPSHIRE'S
LAKES REGION

GHOSTS OF
NEW HAMPSHIRE'S
LAKES REGION

KATIE BOYD + BECKAH BOYD

Haunted
America

Published by Haunted America
A Division of The History Press
Charleston, SC 29403
www.historypress.net

First published 2010

Manufactured in the United States

ISBN 978.1.59629.885.9

Boyd, Beckah.
Ghosts of New Hampshire's Lakes Region / Beckah Boyd and Katie Boyd.
p. cm.
Includes bibliographical references (p.).
ISBN 978-1-59629-885-9
1. Ghosts--New Hampshire--Winnipesaukee, Lake, Region. 2. Haunted places--New
Hampshire--Winnipesaukee, Lake, Region. 3. Curiosities and wonders--New Hampshire--
Winnipesaukee, Lake, Region. I. Boyd, Katie. II. Title.
BF1472.U6B688 2010
133.109742'4--dc22
2010033587

To Chris Gentry…dude, you're in a book!
Also to Gail Sherman…love ya sistah!

CONTENTS

ACKNOWLEDGEMENTS

Beckah would like to thank the many historical societies around the Lakes Region for keeping the past alive. Big thanks to Jeremiah Greer for getting the auto-deejay and filling in for me at the radio network while I took time to co-write this book. Thanks go to Lorrie Gibson and Dori Roberts for being patient and supportive and to Linda Puleo, my assistant, for taking the time to deal with the details. Thanks to my mom for reminding me to breathe! And thanks to the coffee fairy…you know who you are. The biggest thanks goes to my readers; if it weren't for you, I wouldn't be able to do what I love.

Katie would like to thank her many friends and supporters in the paranormal for their great ideas and inspiration. Humongous thanks goes to Chris Gentry for sharing his experience at the Laconia State Prison and to Shannon Sylvia for a wonderful interview. Another thank-you goes to Freya, my office cat, for making me laugh while researching.

Beckah and Katie would both like to thank their editors and the hardworking design department at The History Press for making their vision become a reality.

INTRODUCTION

New Hampshire…filled with mysteries, stories and legends. UFO sightings, ghosts and vampires—even Sasquatch supposedly resides up in the mountains. There are so many books out there detailing hauntings in the Granite State, but we are not here to talk about the whole of New Hampshire. Just one area. Katie and I have done investigations both private and public all over New England, but it's always fun to investigate in our own backyard. Over the ten years that we have been working together, we have debunked, confirmed and questioned more than five hundred places, private residences and businesses in the Northeast.

The Lakes Region held a special challenge for us: Portsmouth, with its hauntings on every corner and old maritime history; Dover, where the mills are known to be haunted and where, at the time, work conditions were less than satisfactory; and Laconia, not only famous for Bike Week but also for its haunted inns, taverns and other hot spots. There was so much to sift through, so much to look at, that we were kind of like kids in a candy store wondering what to do and where to go. A little overwhelmed, we compiled our favorite stories of ghosts and the unusual in the Lakes Region.

This is a case report, a history, but most of all it is a story. Follow us, your intrepid investigators, as we go through the Lakes Regions hauntings; you will read sections that will scare you, shock you, make you feel the warm and fuzzies and even make you pee your pants with laughter. Yes, many people believe that the paranormal is a dark and sinister thing, but by the end of the book you will realize that even the dead have a sense of humor and that every investigator is fair game.

At the end of the book, you will find an interview with a ghost hunter and television personality who has traveled around the world in search of spirits. Shannon Sylvia appeared not just on *Ghost Hunters International* but had an episode on the television show *Paranormal State*. Find out what she learned along her journey and how this skeptic approaches paranormal investigation.

PART I
THE WEIRD AND UNUSUAL

MADISON: THE BIG BOULDER

Sometimes the paranormal is actually very normal—just a little…weird. The last census that took place in this town back in 2000 said that there were about 1,900 people living in Madison, a town of Carroll County. Incorporated in 1852, it was named in honor of President James Madison and was one of the first to give land grants to soldiers who fought and survived in the French and Indian War. This small population lives with a very big piece of natural history: a boulder straight out of the ice age, one of the largest glacial erratics in the world; it is the largest in North America, weighing in at 5,963 tons (11,926,000 pounds). This huge, rectangular piece of granite was deemed a national natural landmark by the United States Department of the Interior in 1970. Up until 1946, the boulder and the land on which it is located passed through a few different owners; finally, the Kennett family bequeathed it to the state as a memorial.

Where did this huge six-ton boulder come from? To give you an exact idea of its size, the boulder is eighty-three feet in length (that's fourteen average five-foot-nine people laid head to toe), twenty-three feet above the ground (it is believed that there is another ten or twelve feet below ground) and thirty-seven feet in width! Not something the average human could move. The granite boulder is made of equal parts fine grain feldspar and larger quartz pieces created from the immense pressures of molten masses beneath the earth's surface more than 200 million years ago. Many believe that the boulder came from about two miles away; they estimate this based on the

boulder's makeup, which is similar to Conway's Whitten Ledge. Others debate that it could also be from farther away—twenty-three miles or more from Crawford Notch—though geologists insist that this is most improbable. The New Hampshire State Department of Parks and Recreation created a brochure for this wonderful monolith, explaining in detail the journey that the boulder must have gone through and how. Following is their explanation:

> *The most recent ice advance occurred during the Pleistocene (ply-sto-seen) Epoch, which is a unit of geologic time that began about 2.6 million years ago. The world's climate had cooled enough to allow snow to accumulate into huge sheets of ice that covered much of the northern half of North America. Here in New England, the continental glacier flowed southward from present day Labrador. As this ice flowed over our hills and mountains, it broke off pieces of rock from the underlying bedrock. Some of these rocks were quite large. The Madison Boulder was probably plucked from Whitten Ledge, less than two miles to the northwest, which is made of Conway Granite. The ice transported the boulder, smoothing its edges, and left it sitting on a different type of rock, called the Concord Granite.*

There are several picnic rocks that you can have lunch on, and the park is open all throughout the year for visitors. Some psychics and sensitives who have visited the boulder have recorded a feeling of their hair standing up on end. Many people within the paranormal community theorize that quartz crystals may heighten the energy of an object or the spiritual energy of the land and that this may be an explanation. There is no real haunting here—merely one of nature's most interesting marvels.

How to Get There

From the south take I-95 N (tolls). Take Exit 4, Spaulding Turnpike/Route 16, on the left toward US-4. Merge on to NH-16 (more tolls). Turn right onto NH-41/Plains Road. Turn right onto Route 113/Village Road. Turn left onto Boulder Road. Go all the way to the end and park in the parking area. Just a short walk up the path and you will see one of New Hampshire's oldest treasures.

From the north get onto NH-16 going south. Turn left onto US-302/White Mountain Highway/NH-16. Turn left onto Deer Hill Road/NH-113. Then turn right onto Boulder Road. Go all the way to the end and park in the parking area.

Lights in the Sky: UFO Sightings

There are so many movies and books and so much media out there about UFOs, aliens and space creatures. Beckah and I have investigated a few abduction claims over the years, and we have found that the Lakes Region and towns nearby are particular hot spots. Sightings occur as far back as the late 1700s and early 1800s; as we scoured the Internet, we soon realized that the Lakes Region is home not just to unidentified flying objects but also unidentified submersibles and watercrafts.

In the central, eastern part of the state is Ossipee Lake, an area sacred to the Indians. In 1800, an Indian burial ground was discovered, an area that contained ten thousand bodies arranged in concentric circles. There are numerous "kettle" lakes in the area that were carved out of glaciers during the ice ages, and ancient volcanoes ring the area. Some of the ponds are considered bottomless and may be connected to each other by volcanic vents. It is said that UFOs have been seen plunging into these deep ponds.

I (Katie) had my own experience, although not in the lakes area; it was about 1985 when I saw my one and only UFO. But I was not alone; my friend Chris was with me. We were walking to my house in Goffstown when we saw this cigar-shaped gray material with red and yellow lights. If I had to estimate how far away it was, I would say it was maybe five or six stories up in the air. I could not even tell you the length of the craft; all I know is that my fifteen-year-old brain could not handle what I was seeing. I was enthralled by this large airship. It was not there for long, though; all of a sudden, it just bolted. It was like Superman when he takes off. Chris and I ran back to my house, which was only about a half block away. We needed to tell someone, and we thought we could do no better than our local radio station; besides, we figured if we were the first to report a UFO to the station, they might give us T-shirts or something for our experience and efforts. We used the request lines a lot on Friday nights, so we knew the number by heart. We got through, only to be told that we were not the first callers; in fact, the station had actually been flooded with calls from all around southern New Hampshire. Every person had seen this same object and given the same description. Now, I know from my own research that UFOs are often seen by whole towns and groups of people; although many still believe that they are individual experiences, it *can* happen where only one person sees them, but it is more common due to the size of the craft that it will be witnessed by

many. It just stunk that we were not the first to call in; I was really banking on some free swag for our efforts.

The Lakes Region holds many secrets, including military secrets; many of the hot spots like Moultonborough, Ossipee and Winnipesaukee have military operation areas. Lake Winnipesaukee is New Hampshire's largest lake by far, spanning twenty-one miles in length and varying from one to nine miles in width. It's also the site for government test facilities due to its proximity to Portsmouth and the controlled lake atmosphere. Therefore, it is possible to believe that people are seeing UFO and USO (unidentified submerged object) activity; these may not be real aliens, but they could be the government testing out new technology. They primarily use the lake to test out sea-missile propulsion research. However, they also do nighttime flying without lights and using night vision goggles.

That being said, let's take a look at some of the different sightings. Within just the last few months of writing this book, I have heard several different reports of UFO sightings, but one in particular was so notable that www.examiner.com published an extensive article about it:

Two New Hampshire teenagers sitting in a parked car were approached by a black-colored UFO in Laconia on March 20, 2010, lifted into the air and then dropped back onto pavement 180 feet away, according to testimony from the Mutual UFO Network (MUFON) database.

MUFON New England State Director Steve Firmani confirmed his investigation of the case today by telephone and said witness interviews had been completed.

The 18-year-old girl and 16-year-old boy both offer testimony about their encounter.

The two used the girl's mother's car and went to a Laconia destination that has not been released.

"We were just sitting there and I looked up at the moon," the female witness stated. "I saw this weird black-shaped object. And then, I said to my boyfriend, 'What was that?'"

Both accounts describe the same events. They saw an object coming toward them from the sky and began to panic. When they attempted to drive away, the car they were operating was lifted up off the ground. Both describe an odd smell during the incident.

When the car hit the pavement 180 feet away, the windshield cracked and the air bags deployed.

Firmani said there was no damage to the body of the car, but that there was about $5,000 damage to the underside of the car.

The male witness described the UFO.

"I don't know how to explain this but it turns into a ball when it wants to slow down and move around quickly and when it wants to go fast, straight, it turns into a flat plate with maze box-shaped lined lights. These were on all the time."

He describes attempting to drive away.

"The front end got picked up and the car could not move. We steered left and right but the car just kept on going up into the air."

When the car hit the ground, they drove quickly away to the girl's home where her mother called the police.

Firmani said there were three-inch divets in the curbing at the impact point where the car hit the ground. He said further study would be made to the under carriage body parts, which MUFON has retained from the body shop.

Laconia is a city in Belknap County, New Hampshire, population 16,411.

This case was originally reported to Peter Davenport at the National UFO Reporting Center. Davenport referred the case to Firmani. The following is the witness testimony from this case.

NH, March 20, 2010—2 Witness Accounts [credited to Peter Davenport—NUFORC]. *MUFON Case #22880.*

My name is E and I'm eighteen years old. I live in Laconia. Last Saturday night, my boyfriend D came up to see me and we went out. When we got to (edited), in Laconia, we parked in the back in the separate parking lot. We turned off the car and it was totally silent.

We were just sitting there and I looked up at the moon. I saw this weird black-shaped object. And then, I said to my boyfriend, "What was that?"

He looked up at it and he said, "If it gets any closer, we need to leave."

I kept staring at the moon to see if it was just a plane or something. It moved back across the moon. It was huge and it looked like it was zig-zagging or changing shape. I couldn't tell.

He said, "I think it's coming closer." It flew so fast over the trees getting closer to where we were. It felt like it was zeroing in on us. It blocked the moon. And then, we started panicking and driving away.

I thought we were going to hit the Bingo building. We turned left but it felt like we went off of a jump—you know that feeling? Like we were on a rollercoaster? And we were in the air. I was trying to pay attention to everything that was going on but it felt like I couldn't. When I looked up, everything was black. The smell was not nice but it was like something you could stand. It was an odor I've never smelled before. I heard absolutely nothing—it was silent. I felt immobilized like I had no control over what I was doing or over my body. I could see nothing. It was like opening your eyes in a pitch black room.

I felt really nervous and scared. I don't remember crying or screaming. I held on to the center console because I felt like I was lifted. I was holding on so tight that my thumbprint is imprinted on the center console.

And then, when I finally realized what was happening, I was so close to the windshield that my body was going forward with my arms behind me. Everything was black. I heard a loud noise like a horn. Once. And then, the car just dropped.

I hit my eye on the dashboard and the airbags came out. I couldn't believe what had just happened. I held my face and I looked over at my boyfriend. I saw that his left arm had blood. I said, "Are you OK?" I looked at the windshield and it was cracked, totally, but only on the passenger side.

I could see D but I couldn't see anything outside. The only thing that made the car drop was the sound of the loud horn. When the car dropped, there was a loud boom. After that, we just drove so fast out of there. The smell went away after we drove away. And I started crying. And I said, "What the h--l just happened?" My boyfriend said, "I don't know, I don't know." I didn't feel like they were following us.

When we got home, my Mom said that she could hear me from the outside while I was freaking out. I couldn't stop crying. My Mom said, "Calm down and tell me what happened." I said, "You're never going to believe me." "Is it my car?" she asked.

And I said, "Let me explain," because I felt that if I didn't explain it fast enough, it was just going to go away from my mind.

At about 12:15 am, a cop arrived. I told him what had happened while I was sitting down at the dinner table. My boyfriend was sitting next to me—it was then that I noticed that there was no more blood on his arm or his clothing. The cop didn't believe me at first until he finished looking at the car. He told my Mom that there was no reason for the air bags to come out because nothing else on the car was damaged. He didn't check underneath the car but we found out later that the underside was totaled. The cop said that he was going to the place where we had been.

I just felt thankful that we'd gotten out of there. But I couldn't stop crying for more than 2 hours afterwards. My Mom said, "You should go take a shower and get the airbag dust off of you." But I didn't want to be alone at all. I felt lucky. And there were no scratches or anything anywhere on my body.

The first night, my dream was that I was a little girl, maybe 6 or 7 years old, in an Elementary School classroom. I was looking at myself as a little girl. And then it was like the teacher called me up and I couldn't talk or say anything—but everybody else seemed to say something for me. Like everything I wanted to say, everybody else was saying it except for me. They were saying exactly what I wanted to say. I have never had a dream like this before—where I am a little girl and see anything about the past. I did not feel right at all.

I am better now. I still worry about seeing this thing again and I pay attention to the sky at night. I really don't go out at night, anymore, because I'm scared.

Second Witness Account:

My name is D. I am sixteen years old and I live in New Hampshire. Last Saturday night I went out with my girlfriend, who lives in Laconia, when we had the following experience:

I was with her around 11. We wanted to take her Mom's car because it was nicer and we wanted to go look at the stars. We went to (edited) at the back parking lot in Laconia. There were 8 cars already there when we arrived. Little by little, the cars started leaving one by one. We were the last car in the parking lot. Then the lights of the parking lot and the lights of the houses around us and the lights of the houses down the street started to go out one by one.

Then my girlfriend noticed something blocking the moon and asked, "What was that?" I knew it wasn't a cloud because it moved back against the wind and blocked the moon again. I don't know how to explain this but it turns into a ball when it wants to slow down and move around quickly and when it wants to go fast, straight, it turns into a flat plate with maze box-shaped lined lights. These were on all the time.

The colors were dim yellowish white and did not change. I cannot tell whether these were part of the bottom or not. It flipped a lot. I did not know which side was right or up on it. It was doing this over the trees across the street from the parking lot. It suddenly crossed the street towards our car. Its

size was as big as 14 houses. It was really quiet. That's when we had to leave. But I did not have time to turn on the headlights.

We put the clutch in to start the car and jammed it into 1st and floored it. The front end got picked up and the car could not move. We steered left and right but the car just kept on going up into the air. My girlfriend was scared and she had boogers coming out of her nose while I was cursing. The car was going up and the back wheels were off of the ground. Then I looked out of my window and saw that the parking lot park lines started getting smaller. Both our windows were down this whole time. The front windshield started to crack and shake and the cracks spread from the passenger side to the driver's side. It popped outward like it was pulled out.

Something yanked my wrist. Not aggressively. And the whole time in my head something was telling me "Don't panic," or "Don't be scared." And it wasn't in English in my head but I got the meaning. It wasn't a language—I don't know how to explain it. And on my girlfriend's side, it had her half-way out of the window. Her butt was off of her seat, maybe one-and-a-half or two feet? And the car was pointed almost completely straight up at the stars—yet I saw no stars.

Every time I tried looking at it, in front, a white film went over my eyes. It was kind of like staring at the sun with your eyelids closed. I could not hear her screaming but I know that she was screaming. My ears felt like they kept on popping from the altitude. I couldn't hear. The smell was like unbearable, like you want to close your nose. It was spicy, like pepper-sprayish, and clean at the same time—it was a smell that you could stand but you would close your nostrils because it still smells bad.

When I tried to fight and get my wrist back in the car, that's when the grip got stronger. It was pulling my left arm up out of the window—there was no pain but it was strong…I was trying to fight off the grip on my wrist. My tongue was numb. The horn beeped by accident and the grip got a little loose. It beeped again in the struggle and my arm flopped down in the car. My girlfriend also fell back in her seat and we realized we were still up in the air.

It took 2 seconds for the car to drop. When we dropped, the air bags came out. We floored it as fast as we could through the town. It was almost a straightaway to go to my girlfriend's house with very few turns to take. During this time, both of us couldn't stop crying. We arrived at her house and her Mom asked, "What happened?" All this took place from 11pm to 12:30 am. It seemed like we were in the air for 10 minutes and it felt like it was forever. Her Mom called the police, and a policeman came.

The policeman did not believe us when we first told him what had happened until he looked at the vehicle. There were no scratches or dents or anything. He said that there was no reason for this to have happened to the car when there are no dents or scratches and no reason for the windshield to shatter and pop out the way it did. He had no explanation for why the windshield popped outward. Also, when I went to open my cell phone in front of the policemen, I got shocked by it.

On Monday, I went to my doctor to get a whole physical to make sure I was OK. My wrist had a puncture wound while my forearm has a cut that is semi-circular and there's blood on it. I do remember that when I first looked at my arm after I got it back in the car, it was red with blood. But by the time we got to my girlfriend's house, there was no blood anywhere. On the center consul of the car, there is an imprint of her hand. I don't quite understand what the policeman said but it was something about the skin of her hand leaving an impression.

Now, I don't like to feel bumps in the car, or feel anything that trembles like a boombox. I don't want to be out in dark areas at night. I also don't like to walk out to my Mom's car, anymore, outside.

Although this is one of the more recent and intense sightings, UFOs and USOs have been seen around the Lakes Region for quite a while. In 1896,

Artist's interpretation of an alien being—what strange mysteries occupy the skies above the Lakes Region?

the first sighting of a UFO over a naval base was seen in nearby Portsmouth by two security officers guarding the bridge to the mainland at the naval shipyard. In a state of shock, they shot at the craft, which deflected the bullets and took off. The years of 1973 and 1974 were particularly productive for UFO sightings in the Lakes Region. Following are several reports from local newspapers at the time of the sightings:

BELKNAP COLLEGE TRIO REPORTS UFO SIGHTING
Laconia Evening Citizen, *March 30, 1973*

CENTER HARBOR—*Three Belknap College astronomy students have reported sighting an unidentified flying object Wednesday night from the college's observatory.*

They reported the UFO was seen from the observatory as they were looking south towards the Belknap Mountain range.

Reporting the sighting were Gene Major, a sophomore from Stanford, Conn., Harry Bridges, a senior from Philadelphia, Penn., and Bruce Wingate, a freshman from Pompton Plains, N.J.

They said the UFO was observed from 8:15 to 8:40 o'clock Wednesday night through a 12.5 inch reflector, a six inch reflector and a pair of 7 x 35 binoculars.

The object was dark red in color according to the students and was about the size of Saturn as seen through a telescope. They said it appeared to be pulsating and rotating at one-second intervals but was stationary at times.

According to the trio the object was about three degrees above the Belknap Mountains as seen from Meredith facing South and about six degrees above the true horizon. They said it appeared to move back and forth in a southeasterly and southwesterly direction.

They reported an airplane did pass overhead about 40 degrees from the sighting and was in no way similar to the object they sighted.

The students asked anyone who also spotted the object to call them at 253-6588.

STRANGE OBJECT SIGHTED IN SKY OVER PLYMOUTH
Laconia Evening Citizen, *September 11, 1973*

PLYMOUTH—*There are reports of sightings of unidentified flying objects.*

Whether it was a UFO or not, a strange object was seen in the western sky about 7 o'clock last Thursday evening. It did not appear to be a plane

and it was moving very slowly. No wings—no lights. It appeared to be like a long, thin, "silver pencil" in the sky and took no definite course, almost hovering.

It was seen about a full moment, however, and it appeared to be moving downward, somewhat counter clock-wise before it suddenly vanished.

AREA POLICEMEN SIGHT *UFO*
Laconia Evening Citizen, *August 12, 1974*

TILTON—"I never saw anything move that fast" said Police Officer Michael Alden, of one of the four unidentified flying objects which he and fellow officer Mark Payne reported sighting in the Interstate 93 area Sunday morning.

Alden said the UFO "went straight up in the air and then south over I-93 at a high rate of speed" before making an arcing turn and then disappearing in a southerly direction.

The first sighting took place around three o'clock in the morning when Alden and Payne were parked facing west on the emergency cross-over near exit 22 on the Interstate.

"We were on the lookout for a car and were parked just south of the Sanbornton exit when we noticed what appeared to be a very bright, flickering star. As we watched it we could see different colored flashing lights, blue, red, yellow, green and white and the object moved back and forth. Then it seemed to be coming closer and Mark suggested it might be a UFO."

"He turned on the blue light on the cruiser and the object moved in closer, probably to within a thousand yards and we observed the outline. It seemed to be saucer-shaped."

"For health reasons we turned off the cruiser light and it went back to its original position. I scribbled down an outline of what it looked like and we turned the light on again and the object again moved towards us until we turned the light off again."

"At this point we decided to call the Belknap County Sheriff's Department and get some other people to observe the same thing. We called and they sent out a unit and a deputy sheriff verified the lights. The objects moved in once while he was with us and Belmont and Gilford also sent officers to witness the sighting."

"We saw two more bright lights, one discovered by another officer toward the northwest, and another in an easterly direction. We thought we could

see shooting stars but they seemed to travel parallel to the ground and didn't burn out. It was as if they were setting up some triangular pattern and the light was travelling between the three points."

"Around five o'clock we observed a fourth object. It appeared to be taking off or rising after hovering low over the ground. It was in the Northwest and went straight up and then south at a high rate of speed above I-93. This one had white lights."

Alden said the objects disappeared not long after the fourth one had been sighted and a call to Franklin Police revealed they had also spotted the object around four o'clock "directly over the city."

Meredith Police reported this morning that officer John Skidds saw an unidentified object over Leavitt Park at around 10:30 last night. He contacted the sheriff's office which also witnessed the object. It remained visible for over an hour before disappearing.

Alden, 19, is the son of Belknap County Sheriff Donald C. Alden and is a full-time officer with the Tilton force. Both he and Payne, 22, also a full-time officer, live in Alton.

Six UFO sightings, including the Meredith one, were reported to the Belknap County Sheriff's Department last night. Other reported sightings were made in the Alton-Wolfeboro area, Laconia and near Liberty Hill in Gilford.

UFO CENTRAL MAY PROBE SIGHTINGS
Laconia Evening Citizen, *August 13, 1974*

Belknap County Sheriff Donald Alden said this morning a report on the rash of sightings of unidentified flying objects in the Lakes Region is being prepared for the director of UFO Central in Chicago and representatives of the agency may launch an investigation soon.

For the third straight night there were several sightings, four in this city, one in Northfield, two in Meredith and two in Tilton.

Alden said photographs taken of sightings Sunday night and Monday night in Tilton are being processed and if any show objects clearly they will be used to document the reports.

Police Chief Harold Knowlton said sightings were reported last night at 8:40, 9:04 and 10:15.

One of the reports said there were "two lighted objects" over Varney Court while reports from Southgate Terrace and Sunrise Towers said they

were "round dome-shaped objects with something underneath" hovering over Boulia-Gorell Lumber Co.

A fourth report from the Brickyard Mountain Inn said a bright object appeared hovering in the sky and then "left real fast."

Officers in cruisers and police cadets responded to the scene of the sightings and observed "objects with blue, green, red and yellow lights" which hovered in the sky and then moved rapidly toward Sanbornton.

One officer reported sighting an object with "a steady green light which moved at a high rate of speed" and said he saw two "very bright lights falling" which might have been shooting stars.

The Northfield sighting was reported around 10 o'clock last night by Alex Biron, a former Air Force crew chief. He was joined in observing the objects by Frank Picknell and Steve Adams of the Northfield Police Department.

"It started with a red light in the sky. I viewed it through binoculars and the object appeared to be pulsating, like you see in science fiction movies. It appeared to have a sold white light at the core, with a pulsing red light that turned to green, blue and yellow as it travelled away from the center of the object."

"Biron said the object was in the Southwest and two other objects were visible in the sky."

"We watched them until around 11:30. Then the object in the center began to settle down slowly and the two others arched over the spot where the middle one had been, one arcing high in the sky traveling west and the other one curving lower toward the horizon to the east."

"I've never seen anything in my life like that" said Biron.

Paul Hough, member of the Evening Citizen press room staff and a resident of North St., said there were about 20 residents of his area out watching the antics of the UFOs over Paugus Bay last evening.

Paul reported they saw three of them in the sky and they seemed to be making X maneuvers. "It looked like they were playing," he said.

They were easily spotted, he reported, the group could see people in cars on the Weirs Boulevard stopping to view them.

For the third straight night UFOs were reported in the Tilton area. The first sightings were reported there Sunday morning between three and five o'clock, with sightings reported Sunday night at 11 o'clock and last night around ten o'clock.

There were also reports of two sightings in Meredith for the second time in as many nights.

Other reports of sightings have been made in Franklin, the Alton-Wolfeboro area and Gilford.

UFO INVESTIGATORS TOUR AREA, PLAN REPORT ON SIGHTINGS
Laconia Evening Citizen, *August 20, 1974*

John Oswald of North Hampton and two other UFO investigators were in the Lakes Region over the weekend to talk to police officers and citizens who had reported sighting unidentified flying objects during the past nine days.

"We got some pretty interesting information," said Oswald, who was here from two o'clock Sunday afternoon until after one in the morning.

Oswald talked with Tilton Police Officer Mark Paine, who along with fellow officer Michael Alden, made the first report of a UFO sighting last Sunday morning between three o'clock and 5:15 a.m. while parked in their cruiser on Interstate 93.

"We had our hands full trying to gather information and it was my impression you could walk down the street and talk to a lot of people who had observed UFOs."

He said he is working on a report which will be sent to UFO Central in Chicago. The data will also be provided to Ray Fowler, local investigator for the national Investigation Committee for Aerial Phenomena.

Two sightings were reported to the Sheriff's department last night, one at 9:30 and a second at 10:50 in West Alton.

Reported sightings of unidentified flying objects dropped over the weekend with only one sighting reported to police Sunday night.

The Belknap County Sheriff's Department received a call at 9:30 Sunday night reporting a sighting in Alton.

Willie King, 11, and Mike King, six, sons of Mr. and Mrs. S.H. King of 11 Champlain St., reported sighting an unidentified flying object Sunday night at 9:51 while they were outside King's Chinese-American Restaurant on Champlain St.

They said the object had red and blue lights and "moved faster than any jet."

They saw the objects for about 40 seconds and said it was about the size of a nickel from where they were standing and was heading toward the Weirs Beach area.

A report was received last week of bright lights in the sky over Lake Winona from Karl West of Winona Road.

He said a group of five or six people were on the shore of the lake Thursday night and saw a steady bright light which moved across the sky

around 9:50 moving from the West to East. The object was visible for about 20 seconds.

West said around 10 o'clock they saw another bright light in the northern sky and at 10:30 looking south they saw three similar lights about five to ten minutes apart.

One was low on the horizon, the second a little higher and the third rose in Sagittarius and moved east.

The intensity of the lights was about the same as the Big Dipper stars and the objects were going more slowly than a meteorite but faster than a jet and left no trail.

UFO Sighted Over Lake Winnipesaukee by Boat Inspectors
Laconia Evening Citizen, *August 14, 1974*

UFO sightings were reported last night by members of the Division of Safety Services and city police received one report of a UFO sighting over Paugus Bay.

It marked the fourth straight night of reported UFO sightings in the Lakes Region.

The area has been undergoing meteor showers in recent days, according to John P. Oswald of North Hampton and Larry Spiegel of Plymouth, a student at Plymouth State College and these may account for some of the sightings.

Oswald is an investigator with the Center for UFO Studies in Chicago which is headed by Dr. J. Allen Hynek and Spiegel is associated with the Mutual UFO Network of Quincy, Ill.

Last night's sightings were reported by two inspectors of the Division of Safety Services over Lake Winnipesaukee.

The first sighting was reported at 9:24 off Bear Island and the inspector said a "bright-colored" object seemed to be hovering over him. He said it was larger than any star and it left at a rapid rate of speed toward the Glendale-Alton area.

He said he couldn't tell how far away the object was and when it did leave it moved at a 45 degree angle "at a far greater speed than an airplane or a satellite."

No trail was observed behind the object, as there would have been behind a meteor.

The inspector waited for 15 or 20 minutes and saw three or four objects heading in a northeasterly direction toward the Melvin Village area.

Another boat was radioed and both met near Long Island where they saw another object headed in a westerly direction.

The object was very large and cast a multi-colored glow but was moving slower than the first one according to the inspectors. None of the sightings were accompanied by any sound.

The inspectors waited near Sandy Island and observed still another object in the vicinity of the Big Dipper, which appeared to be a satellite.

They turned on the flashing light on their boats and said they thought the object appeared to change course and changed course again when the lights were shut off.

The sighting over Paugus Bay could not be verified by local police.

PLAYHOUSE STARS SEE UFO
Laconia Evening Citizen, *August 14, 1974*

Barbara Bel Geddes, the sophisticated movie and theater actress and her Gilford Playhouse costar, husband, Laurence Hugo, today joined other Lakes Region observers who reported viewing an Unidentified Flying Object.

Miss Bel Geddes, starring in a summer stock production of "Finishing Touches" at the Playhouse is staying in a ski chalet on Mount Gunstock.

Sunday evening, she reports, she was sitting on the porch with Mr. Hugo, when she called an unusual object in the sky to his attention.

"It's just Mars," Mr. Hugo told her because the color of the far off object was red and looked like a star or a planet.

Miss Bel Geddes said she thought she saw the object move and they watched it through field glasses for about an hour and a half.

The object was just above the tree line, Mr. Hugo said, and during the time they watched it "seemed to move about 20 feet on a slant away from us." At times they noticed a green light as well as a red one.

Miss Bel Geddes and Mr. Hugo checked with the Belknap County Sheriff's Department Tuesday afternoon after reading accounts of local sightings by police and other witnesses in the Evening Citizen on Monday. They asked whether the Strategic Air Command had been notified and had given any explanation.

They were referred to the newspaper which reported the UFO Central office in Chicago had been notified and were considering sending an investigator.

Mr. Hugo said "We didn't think it was anything. It looked like the red and green port and starboard lights. We thought there would be an

explanation of it all by now. It looked like a balloon to me way off on the horizon, not very far above the earth."

Mr. Hugo said, *"We would have reported it earlier but we're stuck up on the mountain without newspapers."*

TEENAGE OBSERVER DRAWS UFO PICTURE
Laconia Evening Citizen, *August 15, 1974*

More Unidentified Flying Objects were reported to local police last night and a group of 15 young people said they saw a saucer-shaped object through a telescope while observing from Liberty Hill in Gilford.

Duane Champoux, 16, who will be a senior at Laconia High School this year, drew a sketch of the object which he viewed through the telescope.

Champoux said the object appeared to be about a mile away and was viewed at around 10 o'clock. He said there was a red light on the front and a yellow-whitish light at the rear of the object, which was visible for about three minutes.

"We were on Liberty Hill looking East and as I watched through the telescope I could see the outline for five or ten seconds. It moved East to Northeast kind of floating across the sky. It appeared to be a mile away and a couple of thousand feet in the air. I've shot model rockets that have gone higher in the air than the object."

He said while viewing it through the telescope the object appeared to be made of metal. The telescope is 60 power and was magnifying around 35 or 45 times said Champoux.

"It was really a sight to see" said Champoux, who added other observers with binoculars could see the lights.

The Division of Safety Services also reported sightings over Lake Winnipesaukee last night.

The first sighting resulted from a phone call reporting a UFO between Governors Island and Eagle Island at 9:06. A boating inspector went to the Eagle Island at 9:06 and reported no sighting at 9:08 but called at 9:12 to report "a pulsating white light" moving toward Meredith and Center Harbor.

Other sightings were reported by the Division of Safety Services at 9:49 and 10:11.

Laconia police had a report of a sighting at 9:13 near Bear Island which was described as looking like "a large star about 3,000 feet up in the air."

At 9:49 "two white objects" were reported over One Mill Plaza with one of them moving up toward Weirs Beach. The observer said after the first object got to the beach the second object "took off and followed."

At 10:27 two white objects were reported near Brickyard Mountain Inn moving toward Meredith "at a high rate of speed."

It was reported the objects seen over the city took 60 seconds to disappear over Meredith by a person who observed them from Brickyard Mountain Inn.

UFO Central in Chicago said they have been informed of the sightings in the Lakes Region and said they normally receive around 40 calls a month of sightings. Recent sightings have taken place in practically every state.

John Oswald of North Hampton, an investigator for UFO Central, said no team has yet been sent to the area but he may be in the area this weekend to discuss the sightings with police officers.

He urged people making sightings to keep track of the time, location, elevation of the object and descriptions of what they did see.

Photographs are of particular importance to researchers and he said those shooting with a telephoto lens should use a setting of 130 or 160 of a second. If people do not use a telephoto they can try a time exposure of a minute or longer.

CROWDS FLOCK TO HILLSIDES IN UFO WATCH
Laconia Evening Citizen, *August 16, 1974*

Strange UFO sightings were reported in the Lakes Region again last night and UFO watching seems to the latest nighttime craze. Hundreds of viewers were out in force in the Liberty Hill area of Gilford while others have selected the Belknap Mall and Vocational-Technical College on Prescott Hill as prime viewing spots.

Police said sightings were reported to them in Gilford and Meredith, as well as this city. None of the reports could be verified by police.

The Belknap County Sheriff's office said they received calls at 10:30 and 11 last night, one reporting a "blue-pulsating object" over the lake, and another reporting a "landing" by a UFO on Belknap Mt.

Reports to Laconia police were recorded at 9:09, 9:18, 9:47 and 11:02.

The first report described "blue and white lights" over Lake Winnipesaukee which "hesitated and then took off for the Route 11-B area."

The second report came from the Weirs Beach area and described "a cone-shaped object with a green tint and a red glow on the bottom" over the lake.

Two objects with "real bright lights" were reported in the vicinity of Belmont in the third report and the final report was of a "hot dog or saucer shaped" object over Lake Opechee with "red, green and white lights."

Kathy Lagiuex, 12, of 33 Brigham St., reported her entire family saw an "orange egg-shaped object" go across the sky from their vantage point at the Vocational-Technical College at Prescott Hill.

The object was "very bright" and she said it was being followed by three airplanes.

"It dropped something and then we saw it go behind a mountain and disappear. It then started coming up over the mountain and pulsating."

The sighting took place around nine o'clock and was viewed for about 10 minutes by Kathy, her mother and father, her sister, Cindy, 17, and brother, Russell, 13, as well as an aunt and uncle and cousins.

"We could hear airplane motors and see red and white lights on the planes but the orange object moved much faster than the planes. Most of the time we saw it the object was in the vicinity of the red light near the airport and seemed to be a little above it."

UFO Search Turns Up Cold
Laconia Evening Citizen, *August 17, 1974*

Editor's note: Phil Blampied is a free lance writer from Boston who arrived in the Lakes Region on Thursday to investigate the reports of Unidentified Flying Objects. He spent the night cruising the area with the Belknap County Sheriff's Department and he will be writing of his experiences for publication in the Boston Phoenix *and the* National Enquirer. *He wrote this personal report for the* Evening Citizen.

Mostly it was cold.

Sheriff's Deputy Steve Hodges and I stood in a field in Gilmanton. It was maybe three in the morning, but don't quote me. Hodges was keeping the log. I was just trying to keep awake.

After a few hours of riding the regular rounds, Hodges engrossed in police work, me with my neck craned out the window watching to see if any of the stars danced or changed color or otherwise resembled a UFO, we were stopping to give a few minutes to a wholehearted check of the skies.

The trouble at three o'clock is everything moves if you look at it long enough.

"Hey," I suggested to Hodges, "didn't that thing down there just move?"

"I doubt it," he said: "it's a floodlight."

"Wait a minute," I said, undeterred, "What about that?"

"You mean that star?" Hodges asked.

I took my camera out. If what pilots UFOs is anything like humans, they probably have the same enthusiasm about getting their picture in the paper. I waved the lens encouragingly in the direction of the Milky Way. This is when I noticed I was shaking.

"I'm shaking." I said.

"Yeah?" he said.

"I'm not going to be able to photograph the UFO when it swoops down," I protested; "I'm too cold, and when it comes, I'm going to be too nervous."

The problem, it turned out, was academic. Ten minutes later, I was no longer worried about being nervous. It was still cold, but the major difficulty was quickly becoming boredom.

Then suddenly there was some movement on the south horizon.

I think.

You see, these small star-size, orangeish lights would float lazily upward. At least, it looked that way. But then, suddenly, they were still.

"I'm sure they were moving a minute ago," I said, "I mean I think they were."

Five minutes. Then to our right, more orange lights. Two pinpricks, almost treetop level, floating along the horizon. One blinked and disappeared.

"D'you see that?" said Hodges, his professional calm a little shaken. We turned back to the other lights. "If they'd zip across the sky, then we'd know," said Hodges hopefully.

They didn't. Another five minutes and we got back in the cruiser.

Two hours later, the glow of the sun is over the horizon. No more UFOs.

"So," I said to Hodges, "you think you'll tell anybody?"

He shrugged.

Meteorologist Says Some UFOs Defy Knowledge

Aircraft and helicopter lights as well as meteor showers may account for some of the sightings of unidentified flying objects in the Lakes Region recently according to Dr. William K. Widger of Biospheric Consultants International in Meredith.

The well known meteorologist said there are some reports, especially those of Tilton police officers Michael Alden and Mark Paine, "which simply defy rational explanation."

He said the month of August is noted for meteor showers and the area had been undergoing these in recent weeks. Refraction and distraction of lights caused by different atmospheric layers could also account for some sightings.

Another possible explanation may have been maneuvers conducted by the Air Force over the Lakes Region the weekend before the sightings. Many military aircraft were also visible high in the sky during the week.

Widger said after all possible explanations have been made for the sightings there still remains "a residue of cases which can not be explained."

The first sighting occurred between three and 5:15 a.m. on Sunday, Aug. 13. Officers Alden and Paine made tape recordings of their observations and the following are condensed excerpts from the tapes.

ALDEN: *"At times it is silhouetted in the sky, about a quarter mile away, it just dove away."*

ALDEN: *"We flash our blue lights at it, and it seems to flash back. It just wheeled around, swiveling around, with blue and red lights. It's now about a half to a quarter mile away. The lights get bright, then dull. When we flash lights, it responds by changing colors."*

VOICE: *"I don't know about you but I'm nervous as hell. Look at 'em moving. Look at 'em change! It's coming at us. Look at 'em dive!"*

VOICE: *"We see a beam from time to time come down from it…when we flash our blues it gets closer—flash the blues. Be advised that this thing is signaling us back."*

(Sounds of light switch clicking on and off.)

VOICE: *"Hold it, hold it! Look at them respond to this baby."*

VOICE: *"You know what's going to happen? We're going to be called a bunch of lunatics."*

Paine and Alden were joined at this point by Steve Hodges, deputy from the Belknap County Sheriff's office. Hodges confirmed their sightings, although the object had retreated from its closest point of an estimated 1,000 yards to a mile or so back in the sky.

The three were also joined by police from Belmont and Gilford, and several police watched the object at a distance in the sky until it faded with the dawn. Shortly before dawn, though, according to Deputy Hodges, a second UFO rose from the horizon, "reached the sky directly above us and then just went shooting down Route 93."

HELICOPTER MAY HAVE CAUSED UFO REPORT
Laconia Evening Citizen, *August 23, 1974*

Four UFO sightings were reported to city police last night and one of the officers who checked out the reports said he saw lights of what he thought might be a helicopter.

Three of the sightings were in the Memorial Park area and one was made by a wife and husband who reported they saw a UFO heading toward Weirs Beach.

The first report at 8:54:06 was of an object in the sky over Memorial Park with red and underside which had a light on top and was revolving.

At 9:42 a report was received from the husband and wife, of the object heading towards the Weirs Beach area with a white light on the front, a red light on the top and blue lights on each end. There was no noise the couple reported.

At 9:44 a woman called and said she saw a UFO over Memorial Park with red and yellow lights.

At 10:35 a call was received from South St., reporting a couple of UFOs trying to land in the woods.

The police officer who responded to the scene reported sighting an object low in the air which appeared to be a helicopter.

What caused this influx of UFO activity? Looking at national headlines, there were abduction cases almost every year between 1973 and 1980. Whether they were test flights, helicopters or actual aliens we will never know. But those around the Lakes Region know that there is UFO and USO activity; most will not openly discuss it. It is one of the Lakes Region's best-kept secrets. So if you happen to be on Lake Winnie or driving near Gunstock, keep your eyes on the sky.

WINNIE: LAKE WINNIPESAUKEE'S MONSTER

There's a monster in the waters of Lake Winnipesaukee…or not, depending on whom you talk to around the lake. Not only do we have a possible lake monster, but in some stories that are told there are also connections to the Loch Ness Monster. Many, in fact, believe that Winnie is Nessie's baby; others believe her to be a cousin of Nessie. Following is the legend.

Loch Ness. *Courtesy of Tyler Morrison.*

One day, the Laird of Loch Ness, tired of all the monstrous cryptids eating his fish and overrunning his property, decided that it was time for them to leave. But he loved Nessie, so instead he asked that her children be sent away. Nessie loved having her children around her, but they were getting larger, and she wanted to keep her territory. So she sent the children away, as the Laird had asked. Nessie told the children to go to lochs nearby so that they could still meet, talk and play together. Winnie decided to do just that and began following different river systems; she ended up getting very confused with the lefts and the rights that she had to take and ended up in the big water of the Atlantic Ocean. There she saw so many different animals to play with that she got very distracted. One day, she discovered an underground tunnel; thinking that she would take it to go back to her mom and the loch, she swam into it. What she did not know was that over the time of her playing with the other fish and exploring the new big loch, she had swam to another country altogether and had just entered into Maine. She swam and swam, eventually coming to another big lake. She poked her head up and, not seeing anyone around, figured it would be a safe place for her to stay, with plenty of fish and animals to play with.

Lake Winnipesauke.

The tunnels that she took to get to this big lake collapsed after her entrance because of her size. The lake she ended up in was Lake Winnipesaukee. Winnie has grown up but never forgotten her mom; every once in a while, she pokes her head up above the water to see if maybe she is there.

One of her brothers seemed to have taken an alternate route; now known as Champ, he hangs out in Lake Champlain. Her other sister, Sylvie, paddles around the pool at Silver Lake in California. It seems that the other siblings decided to stick around in Scotland: Morag decided to go over to Loch Morar (a short 89.0 miles from mom), Shielagh went to Loch Shiel (70.9 miles from mom and less than 40 miles from Morag) and, finally, Lizzy lives in Loch Lochy (about 34 miles from mom and the farthest from her siblings, a momma's girl).

We can't be sure if any of these immigrant sea serpents ever get together and talk; I would imagine that would be difficult, but I wonder if they know about their other cousins? There is Bessie in the South Bay of Lake Erie Pennsylvania, Tessie of Lake Tahoe, Chessie of Chesapeake Bay in Virginia and Hodgee of Lake Hodges located in California—in addition

to innumerable unnamed creatures of similar description in other parts of the country.

To establish the probability of Winnie, we must first establish the idea that her mother (or cousin) Nessie could be real. Sightings of Nessie go back to AD 565. In this case, an Irish Catholic holy man named St. Columba was also alleged to have seen and stopped Nessie from attack. Adomnán, a hagiographer and abbot of Iona, wrote an important tome entitled *Vitae Columbea* about the life of this saint and founder of Iona. Within the book, written nearly a century later, he describes an encounter Saint Columba had with the sea serpent of the River Ness:

> ON another occasion also, when the blessed man was living for some days in the province of the Picts, he was obliged to cross the river Nesa [the River Ness]; and when he reached the bank of the river, he saw some of the inhabitants burying an unfortunate man, who, according to the account of those who were burying him, was a short time before seized, as he was swimming, and bitten most severely by a monster that lived in the water; his wretched body was, though too late, taken out with a hook, by those who came to his assistance in a boat. The blessed man, on hearing this, was so far from being dismayed, that he directed one of his companions to swim over and row across the coble that was moored at the farther bank. And Lugne Mocumin hearing the command of the excellent man, obeyed without the least delay, taking off all his clothes, except his tunic, and leaping into the water. But the monster, which, so far from being satiated, was only roused for more prey, was lying at the bottom of the stream, and when it felt the water disturbed above by the man swimming, suddenly rushed out, and, giving an awful roar, darted after him, with its mouth wide open, as the man swam in the middle of the stream. Then the blessed man observing this, raised his holy hand, while all the rest, brethren as well as strangers, were stupefied with terror, and, invoking the name of God, formed the saving sign of the cross in the air, and commanded the ferocious monster, saying, "Thou shalt go no further, nor touch the man; go back with all speed." Then at the voice of the saint, the monster was terrified, and fled more quickly than if it had been pulled back with ropes, though it had just got so near to Lugne, as he swam, that there was not more than the length of a spear-staff between the man and the beast. Then the brethren seeing that the monster had gone back, and that their comrade Lugne returned to them in the boat safe and sound, were struck with admiration, and gave glory to God in the blessed man. And even the barbarous heathens, who were

present, were forced by the greatness of this miracle, which they themselves had seen, to magnify the God of the Christians.

Keep in mind while reading this account that Adomnán wrote this more than a century later, not to mention that he does not speak of Loch Ness but rather River Ness—this tributary actually ends out in the North Sea and is what feeds Loch Ness its water. Loch Ness is actually one of the only lakes that does not have any serpent tales whatsoever, until the "Surgeon's Photograph." While this first sighting is interesting and fun to read, it is modern sightings that we rely on in order to gather data, as these can be documented more proficiently with current technology. Since the time of the infamous Surgeon's Photograph in 1933, there have been more than four thousand sightings of this elusive creature, and looking for Nessie has turned into a booming industry. Mackay Consultants of Inverness once claimed that it reached upward of $50 million per year! What about that photo? Well, it likely was an accidental fake or, rather, a misunderstood sighting.

Many of the Nessie photos captured at the loch are just that, but the Surgeon's Photograph stands as the iconic image of Loch Ness. Skeptics claim that it may, in fact, be the tail of an animal diving into the water, such as an otter or the head of a water bird. Some even went to the extreme of saying that it was a massive hoax staged by none other than Ian Wetherell and his stepbrother, Christian Spurling. If you do not recognize the last name Wetherell, you should; he was a big game hunter hired by the United Kingdom's *Daily Mail* back in 1933 to write a story about tracking this creature. He came upon some prints that he thought could be those of the infamous monster; however, they turned out to be those of a dried hippo's foot that had been made into an ashtray. His reputation in ruins, Wetherell disappeared.

Gossips even say that this respected surgeon got in on the joke simply because he thought it would be a good laugh. Evidence shows that this was not the case. The doctor in question, Colonel Kenneth Wilson, didn't initially come forward to claim the photo—hence why it is more widely known as the Surgeon's Photograph and not the Wilson Photograph. A very good reason came to light in the book *Nessie: The Surgeon's Photograph* by David Martin and Alastair Boyd: he was on a trip with his lover, while his wife was back at home. It was asserted that he stopped, not because he saw something on the water but because he had to relieve himself. "Monster" was not a term that Wilson ever used to describe the creature; he simply stated that it was an animal that he did not recognize, and that word came later. He was very curious about what it could have been.

Skeptics also assert that there was a deathbed confession that Wilson gave saying that he and the two brothers (Wetherell and Spurling) had created a toy boat and had carved a monster's head on top of it to restore honor to the Wetherell family. That never happened either. Wilson went to his death continuing to claim he saw something—but what? We will never know for sure. But again the skeptic rumor mill continued to swirl, as people tried to debunk his infamous photos; some even going to the extremely implausible theory that maybe it was an elephant's trunk sticking out of the water—yes, an elephant in the waters of Scotland.

Whatever the case may be, after the photo came to light, Nessie hysteria hit. Thousands flocked to the loch to look for the elusive cryptid. Monks, doctors, police, farmers and tourists have all claimed to see this creature rise from the lake. There is a wonderful informational website called www.loch-ness.org. Tony Harmsworth, who owns and operates it, has lived on the loch for more than twenty years. In that time he has only once seen something he could not identify as activity natural to the area. He also keeps logs of all of the most infamous sightings and provides videos, photos and more of people's experiences. He is also a skeptic, but not in the way that most people think. From reading his website, you get the feeling that he does believe that something is out there, but what it is exactly is open for debate. You also get the sense that he gets annoyed with the tourists when they claim after being there for two days that they have had sightings, while he has been there for more than twenty years and has had only one experience. Many of these sightings are false in that they are often boat waves, ducks or even eels that reside in the lake.

So is Nessie real? We can't say for sure; however, there is evidence that goes to show that there existed a dinosaur similar to what many enthusiasts are claiming to be this large lake monster: the plesiosaurus (the word means "near lizard"), so titled by William Coynbeare. Mary Anning discovered the first plesiosaurus and went on to become a world-renowned paleontologist and even a muse for poet John Kenyon. But her beginnings were simple; her dad had taught Mary and her brother how to look for shells and fossils on the beaches of Lyme Regis. The area was known for its great Jurassic-period marine fossils. Constance Hill wrote about Mary Anning in her book *Mary Russell and Her Surroundings*, with illustrations by Ellen G. Hill. In the book, she describes a conversation she had with the future paleontologist:

> *My father, a dabbler in science, with his hammer and basket was*
> *engaged in breaking off fragments of rock, to search for curious spars*

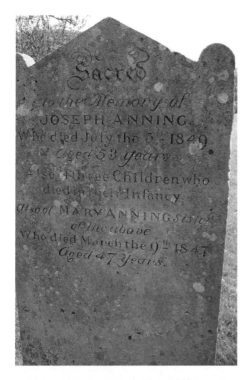

Left: Joseph Anning's headstone.

Below: Cast of the plesiosaurus fossil found by Mary Anning. *Muséum national d'Histoire naturelle, Paris.*

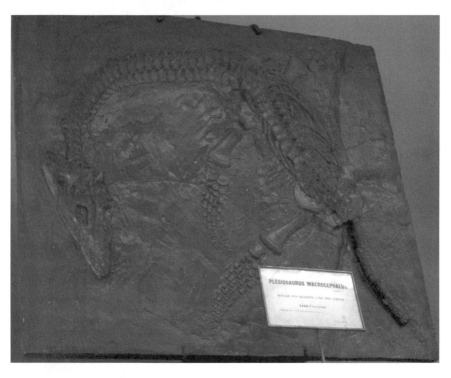

and fossil remains; I in picking up shells and sea-weed...What enjoyment it was to feel the pleasant sea-breeze, and see the sun dancing on the waters, and wander as free as the seabird over my head beneath those beetling cliffs!

Now for a moment losing sight of the dear papa, and now rejoining him with some delicate shell, or brightly coloured sea-weed, or imperfect coruna ammoris, enquiring into the success of his graver labours, and comparing our discoveries and treasures.

What pleasure too to rest at the well-known cottage, the general termination of our walk, where old Simon the curiosity-monger picked up a mongrel sort of livelihood by selling fossils and petrifactions to one class of visitors, and cakes and fruit and cream to another. His scientific bargains were not without suspicion of a little cheatery, as my companion used laughingly to tell him...but the fruit and curds were honest, as I can well avouch; and the legends of petrified sea-monsters, with which they were seasoned, bones of the mammoth, and skeletons of the sea-serpent have always been amongst the pleasantest of my seaside recollections.

Perhaps these "legends" had a tinge of prophecy in them, as it was only fifteen years later when Mary Anning, then a child of eleven years old, discovered in the rocks of Lyme Regis the gigantic fossil bones of the ichthyosaurus, a creature whose very jaw, it seems, exceeded six feet in length and whose existence had hitherto been unknown. She also discovered later on the remains of the plesiosaurus.

Mary Anning discovered the plesiosaurus within the same rock strata as her earlier find. It is a combination of both reptile and fish; skin samples that have been found indicated that it did not have scales like a fish but rather a smooth skin like that of a boa constrictor or a dolphin. It is believed that it ate fish and mollusks and was potentially a bottom feeder as well, so clams and snails could be added to its list of dietary delights. But how big did it get? Well, of the animals that fall under the name of plesiosaurus, the smallest of the species grew to eight feet, and the largest could reach upward of forty-five feet in length. However, the most recent account, aside from Nessie and her brood, was more than sixty-five million years ago in the Cretaceous period. We also know that there have been findings of plesiosaurus in Loch Ness itself (which is relatively young, geologically speaking, as it is only twelve thousand years old). The National Museums of Scotland discovered some bones but determined that they were millions of years old—not our Nessie. So how plausible is it that our sea monster is a plesiosaur?

Richard Forrest runs the website www.plesiosaur.com, and he gets very frustrated with the question—so much so that he has a whole page dedicated to "A Few Reasons Why the Loch Ness Monster Is not a Plesiosaur":

Loch Ness can't support a population of large carnivorous animals:
Loch Ness is a cold, deep lake, and has steeply sloping shores. This means that most of the water is cold and dark, and does not support much biological activity. If the Loch Ness monster is a plesiosaur, plesiosaurs would have to have survived for at least 65 million years. This could only happen if there was a substantial number of animals which would have formed a population large enough to avoid the problems of inbreeding. Loch Ness is neither big enough or productive enough to support such a population.

We would see them come up for air:
Although plesiosaurs lived in the water, they were air breathing reptiles. Even if they could submerge for a long time—marine turtles may be able to remain submerged for as long as five hours—they would still have to surface several times a day.

We would find the bones:
If there is a breeding colony of plesiosaurs in Loch Ness, some will die. Usually when a large animal dies, its carcass sinks to the bottom of the lake or sea. Bacteria in the guts of the animal generate gas, and after a while it floats back to the surface. After a while, the gasses escape and the carcass sinks to the bottom again, usually rather disintegrated. If there were plesiosaurs in Loch Ness, the floating carcasses would occasionally be seen, and would sometimes be washed up on the shore. On the other hand, it is claimed that the waters of the loch are so cold that this fermentation is delayed until the carcass has disintegrated. If this is the case, the loch is probably too cold for a colony of plesiosaurs. Carcasses decaying on the shore would leave bones behind, and if plesiosaurs have been living in Loch Ness for a long time, there should be plenty of bones to be found.

Loch Ness is too cold:
Reptiles do not generate their internal body heat, which is why they live in warmer climates. Marine reptiles in particular need to live in relatively warm water as they can't hibernate to survive cold winters. Large leatherback turtles are occasionally found further north than Scotland.

So we have established what? Yes, there could be something in the water; many scientists and experts believe that if there is any giant to be found there it would probably be a sturgeon, but there is nothing substantial. With the age of digital cameras and Photoshop, you can't really trust either photos or video. In order to bring substantial evidence, both professional and amateur cryptozoologists have their work cut out for them to capture a monster.

I know we have gone on about Loch Ness and the monster supposedly located within; however, as was said at the beginning of the chapter, if Winnie's famous mom cannot be found or proven, then how could Winnie exist at all? In all of our searching and listening to local folks, the stories for Winnie sightings are few and far between—there are more skeptics than believers. Unfortunately, Winnie is one of the least substantial mega monsters; during our investigations, we have not been able to find photographs, video or many if any stories from reliable sources. If there are people out there who have them, we would love to see, watch or hear them.

How to Get There

We suggest checking out Bear's Pine Woods Campground; it's a five-minute walk to Winnipesaukee along one of its many nature trails. Turn right onto NH 25/Daniel Webster Highway/Winnipesaukee Street. Continue to follow NH 25. Turn right onto Moultonboro Neck Road. Turn right onto Barrett Place. Number 65 Barrett Place is on the left.

PART II
INNS, MILLS, TOWNS AND TAVERNS

K atie and I have come to recognize that inns and taverns are notorious for their haunts; sometimes the owners will create outlandish and overly embellished stories of their hauntings. Yes, the paranormal is that big of a market now. Using the spirits as novelty attractions is big. But there are some out in the Lakes Region that are genuinely haunted; we have investigated and gathered evidence, both from our own experiences and those of others. We find that those with real hauntings may highlight that fact but do so with respect, opting for education instead of a ghostly circus. One of the definite bonuses to investigating public places is that, typically, the historical research has already been done, so on that end there isn't too much legwork—unless it is finding individual names that might be a little more obscure. We both love doing private investigations; although there are not as many people to gather data regarding personal experiences as there are at public places, there is a great satisfaction in knowing that you have helped a family, whether the issue be mundane or otherworldly.

TILTON: THE 1875 INN

Most inns were homes at one time or another, and the 1875 Inn is no exception, but the tragic history on which this building stands has not been forgotten; indeed, the spirits will not let you forget. This particular inn is home to a little girl name Laura, who died in a fire more than one hundred years ago. The inn's website gives an accurate accounting of its history:

The sign at the 1875 Inn, Tilton.

The 1875 Inn at Tilton was originally built as a country inn for housing guests visiting the area. For years guests have enjoyed the charm of the Winnipesaukee River that meanders through the downtown area, the likes of Henry Ford and Thomas Edison have been known to [enjoy] the scenic Tilton village.

 The original building was not what it is today; shortly after it was built the owners expanded into the barber shop next door. The beautiful fieldstone fireplace and the raised paneling in the dining area are original to this building. At this time the police station was housed in the basement of the inn. Later a fire broke out in a neighboring building and damaged the top floor of the inn, which was later rebuilt in a different fashion.

 The restoration of the inn began in January 2001. The building had been neglected and sat vacant for 5 years before Joanna Oliver took on the project; renovations included raising a section of the building to replace the foundation, adding support to the second story structure and replacing the long bank of windows across the front with reproductions of the original windows.

Inns, Mills, Towns and Taverns

The *Concord Monitor* recently wrote about Joanna and the 1875 Inn in May 2010, giving with great flourish the back story about how Joanna came to know Laura was there:

> *Nine years ago, Joanna Oliver, owner of the 1875 Inn in Tilton, was painting flowers along the doorframe of a second-floor room, just days away from opening the renovated inn.*
>
> *She felt a tug on her blouse, and turned to find an aged, rail-thin woman, maybe 5 feet tall and close to a century old.*
>
> *"Are you Joanna Oliver?" the woman, who identified herself as Mrs. Giles, asked. "I have something to give you."*
>
> *With a wrinkled, vein-marked hand, she held out a black-and-white photograph of a 12-year-old girl named Laura, looking solemn in a dark dress. The girl, Mrs. Giles said, had lived at the inn in the 1800s and was killed in a fire.*
>
> *"She perished here, and she's still here," Mrs. Giles said.*

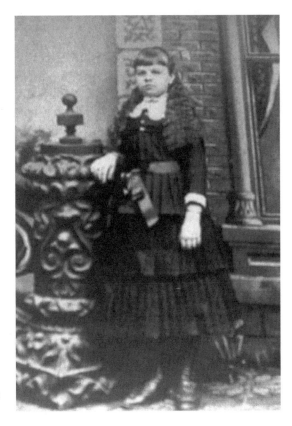

Laura, the little girl who died in the fire.

"Oh yeah, right," Oliver thought. But she accepted the photo and thanked the woman with a laugh. She turned to put down her paintbrush, and the old woman was gone.

Then, Oliver says, *"some incredible things started happening."*

The first NASCAR race weekend in Loudon that the inn was open, a woman ran downstairs in a towel, still drenched.

"Are you people crazy? Why do you have a teenage girl running around my room while I'm taking a shower?" the woman asked, according to Oliver. Told there was no such girl at the inn, the woman turned *"white as a ghost,"* ran upstairs and left, Oliver said.

And then there was the hulking biker—*"6'2" and a couple hundred pounds"*—who was a repeat visitor to the inn.

"He said, 'Joanna, you just rented me a room that a girl came out of,'" Oliver remembered. *"I'm thinking, 'Oh my god, it's Laura.'"*

He followed her up the stairs and stood behind her as she opened the door. Inside, the bed had a fresh indentation, as if someone had just gotten up.

If this sounds like a classic ghost story and nothing more, Oliver says about a dozen groups of paranormal investigators over the years have attested to Laura's presence.

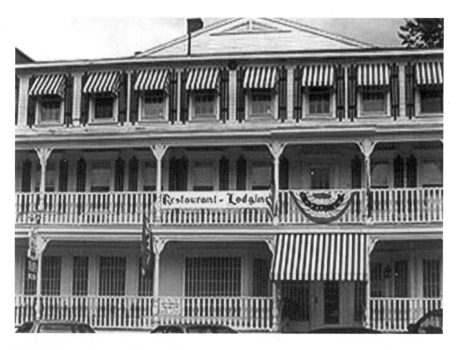

The 1875 Inn. *Courtesy of Joanna Oliver.*

We were called by the owner of the 1875 Inn, Joanna Oliver, to come in and investigate.

When we arrived, it was still light out but edging toward evening. Katie and I had plenty of coffee, so we were ready for a long night ahead of us. The first thing we usually do, even before meeting with the client and getting their take on the haunting, is what we call a walk-through. This is where I, as the psychic medium, go in and give my assessment of the spirits and hot spots in the building. First, we started in the basement. There was a man down there; he was fairly quiet, though, and not intrusive in any way. He actually seemed to have a calm energy around him and talked about digging; it later came to our attention that Joanna had an archaeological dig done down there. It wouldn't have surprised me if people claimed that they felt watched while down there, as he was a man of fairly large energy but not one to make himself known too readily.

The second floor seemed to have the most activity. The spirit of a twelve-year-old girl was there, along with her mother. The mother kept telling me that the little girl was supposed to be in bed. I received the distinct impression of fire, which was consistent with the history I was told later when talking with the owner. While up on the second floor in the Charles Tilton room, I saw a little girl; she had dark-colored hair and was about twelve or thirteen. She was a sweetheart and talked about how she liked to watch the people pass by. This girl fit the description of what Joanna Oliver believed to be her resident ghost, "Laura." The male spirit who walks both the second floor and attic (since converted to more rooms for rent and an apartment, which houses the innkeepers) was a dignified figure. I remember

The hallway leading upstairs to the apartments.

getting the very real feeling that I was standing next to someone important to the town—maybe even the state. He had a strong opinion of the things around him, although I did not feel that he always saw things from this time. I felt that he liked his time better than ours. We were given the Sanborn room to use as our own on the second floor; that place had its own energy and activity. More than once we felt the air grow chill while the heat was up. We looked for drafts and could not find enough to explain it away, especially when the cold spots kept moving.

When we talked to Ray and Ken, they said that it is believed that our room is where Laura perished in the fire. They said that they often smell smoke in this area. We called out for knocks and raps but got minimal responses. We then headed to the opposite end of the second floor; in the back to the far right were two rooms. When the psychics had mentioned to the owner that they were drawn to these rooms, the owner had actually laughed—from the guests and her own experiences, she had theorized that the area was one of the most active in the house. While there, we did receive communications through the K-II meter, and on film we could easily make out orbs passing by the tool when it lit up.

We did get some EVPs that night, although it's not exactly surprising—in a building that really had no one, there was a lot to be heard, including one instance when Katie and I were on the stairs up to the second floor and heard a female voice say, "Oh God."

We also did a dowsing wand session, which proved successful. As Laura came to talk to us, Katie could feel the bed that she was sitting on dip a little bit. During the conversation, Laura talked about how she really liked Joanna and how she likes the attention she gets. Her mother is more of a quiet character at the inn but equally respected. Every month, Joanna holds a paranormal night at the inn; to join in requires just the cost of the meal. The 1875 Inn is a beautiful place with so much history and so many spirits. I would suggest going there on one of the paranormal nights and hearing some of the stories from the locals. Book a room and maybe little Laura will hop on the bed and play with you.

How to Get There

Take Interstate 93 to Exit 20. At the end of the ramp, go right, toward Tilton Center. Follow the road 1.5 miles; on the right will be the 1875 Inn next to the Tilton Town Hall.

GILFORD: KIMBALL CASTLE

A prominent railroad magnate with a bunch of money and a tinge of eccentricity built this beautiful structure. His name was Benjamin Kimball; the project started in 1897 and was completed in two years. The famous boat *Lady of the Lake* was used as a place where Kimball's Italian stonemasons could live while building his castle. This beautiful piece of history cost Kimball about $50,000 to build. The castle is almost an exact replica of one that Kimball saw on the Rhine in Germany while on vacation. Kimball spent winters at his mansion and summers at the castle; he also built a railroad station at the bottom of the hill on his property so that he could take his private car between his work and home. The castle stayed in his family until 1960, when Benjamin's daughter-in-law, Charlotte, died; in her will she put a provision for the castle, saying that it should never be used for commercial purposes. She also left the castle, lands and a few hundred thousand dollars to charity on the stipulation that the organization create a nature preserve on the site. The attorney general's office eventually took over the property rights to the castle and its surrounding grounds and offered it to the town of Gilford, hoping that they would honor the facets of Charlotte's will. The town of Gilford refused to spend the money restoring the castle and creating the nature preserve. Eventually, the attorney general removed the stipulation that the building not be used for commercial purposes. The town of Gilford took on the property, creating ski and walking trails, as well as the Locke Hill Nature Preserve.

There have been many different sightings there of a woman standing in the windows; the current tenants live in the carriage house and report that doors are locked and unlocked, as well as opened. Books have flown off shelves, footsteps have been heard and lights switch on and off.

How to Get There

From I-93, take Exit 20 and then take U.S. Route 3 N/NH Route 11 E about 12.1 miles until the north end of the Laconia bypass. Turn left to stay on NH Route 11 and continue about 3.7 miles to the driveway. Turn right at the hiking trail symbol.

DOVER MILLS

You cannot write a book about the Lakes Region's haunting history without talking about the fire at Cocheco Mill No. 1. It was the worst fire ever to be reported in the town of Dover and located right near the jails on the Strafford County Farm. An inmate wrote a poem about it as he watched the place burn:

> *Firemen grieving and struggling bravely,*
> *People running, rushing madly,*
> *Hear the shrieks amid that chaos of despair.*
> *Some are helping, toiling blindly,*
> *Others soothing in tones kindly,*
> *Oh, God, tis more than human eyes can bear*

Indeed, it was truly a horror to behold the morning of January 26, 1907; it started out like any other. Millworkers were ready for their typical day of labor at the manufacturing company. As spinners, doffers and weavers, the employees all told numbered about six hundred. The mills themselves were considered the height of available technology, with sprinkler systems and safety practices regularly reviewed. However, that did not stop the tragedy that occurred during late January. The *Foster's Daily Democrat* wrote a two-part story on the fire the day it happened. It detailed the heroism, pitfalls and carnage wrought by the conflagration:

> *One of the most disastrous fires that ever visited the city broke out at No. 1 mill of the Cocheco Manufacturing Company this morning at about 6:30 o'clock. The alarm was sounded from box 9 at the junction of Main and Washington Street at about 6:35 o'clock and the fire department responded with promptness to the scene but after their arrival they worked slow and appeared lost as to what to do. The fire appeared to be all on the fourth story at the time that the fire department arrived. As soon as the fire broke out in the mill the operatives became panic stricken and rushed about in their attempt to escape from the burning mill. Some jumped from the fourth story windows to the ground and were seriously injured. A rope was made fast to the inside of a window of the fourth story on the east end of the mill and a dozen or more whose escape to the stairway had been cut off by the flames and smoke made their escape from the burning building by sliding down the rope and those who went down this way had their hands burned*

and lacerated in a terrible manner. The fire broke out about midway of the building on the fourth story and those who were employed in the east end had their means of escape by the stairway cut off and they had to either jump from the windows or meet death as there was only one fire escape on the building and that was on the backside.

Thomas Knott, overseer of the dressing room, which is on the top floor of the annex to the mill, as soon as he discovered the fire, set to work to warn his help that the place was on fire and to get out as fast as they could. After notifying all that he could, he started to make his escape from the burning mill and he found that his path to the stairs had been cut off by smoke which had filled the mill to such an extent that he and a half dozen others made their way to a window on the backside and made their way out by going down the fire escape. He said that many of those employed in his room were unable to obtain their clothing and made their escape into the open air thinly clad with the glass registering about ten above zero and a hard snow storm prevailing outside.

William Turner, employed in the spinning room, when he found that his way to the stairway had been cut off by the fire and smoke, and the room in which he was in, filled with smoke so that I [sic] was almost suffocating, went to the window on the east end of the mill and jumped from the fourth story window, fracturing his hip bone, besides being otherwise injured. He was taken up and carried to a house at the corner of Washington and River streets.

Mabel McKone, Assistant Marshal Wilkinson, Officers Cornell and Young were early on the scene. As soon as Marshal McKone learned that some one had been injured he went to the telephone and ordered the ambulance out, which was promptly driven to Washington Street where it was held, waiting orders. Marshal McKone also telephoned Drs. George P. Morgan, George A. Tolman and Stephen Young that their services were needed in the vicinity of the fire.

James Ashburn, who was employed in the spinning room, found his escape by the stairway cut off and he went to a window on the fourth story of the building, jumped to the ground, breaking one leg, besides otherwise injuring himself. He was picked up in a half dazed condition and carried across the street to the house at the corner of Washington and River street and he was cared for until the arrival of the ambulance where he and Turner were taken to the Wentworth hospital where they had their injuries attended to and were made as comfortable as possible.

Four other men who slid down the rope from a fourth story window, had their hands badly burned and lacerated, besides being otherwise injured

in making their escape from the burning building. Their names are Theo, Bianas, Alfred Barron, Thomas King and Jas Pappas. They were also taken to the same house where Turner and Ashburn had first been taken and later conveyed to the Wentworth hospital.

Supt. of Streets John R. Worster was early on the scene and when he learned that people had been injured he had the city teams attached to sleds and getting blankets which were placed on the sled bottom and proceeded to near the scene of the fire. The four men who slid down the rope were taken on one of the teams driven by Mr. Wentworth and after being taken to a house across the way, were taken to Wentworth hospital. Those who made their escape from the burning mill were all very thinly clad as they were unable to get their clothing, some being barefooted and they suffered much from the severity of the weather and storm.

Agent Fish was quickly on hand at the fire. He was here, there and everywhere in his endeavors to have the fire extinguished.

Five streams of water were placed on the burning building from the Washington Street side of the mill but the pressure of the water service appeared to be very poor, and very little water could be thrown upon the blaze when it reached the floor of the fifth story. The steamer Cocheco 2 was taken to the city farm at the end of the Washington Street bridge and was quickly set to work.

There was much delay in getting Steamer Fountain 3 to the source of the blaze for some reason or another and it is said that word was sent to Portsmouth for assistance. This looks like very poor judgment or mismanagement on the part of some one. Fountain 3 on reaching the scene of the fire was placed in the mill yard where it could draw water from the river and the steamer did fairly good work after it got down to business although it was reported to be in need of repairs.

Agent Fish had all the steam pumps of the corporation at work as quickly as possible after the fire was discovered and they did good work, but the fire had gained such headway that it seemed impossible to stop the flames.

William Hanson, who operated the portable engine on the Cocheco Company's lot on Main street where the ledge is being removed, was early at the scene of the fire. He saw a woman at the window of the top floor of the mill over the main entrance to the building and he heard her screaming for help. Mr. Hanson rushed into the building and went to the woman's assistance. The smoke was dense as he proceeded up the stairs and it seemed as if he would suffocate but he covered his mouth the best he could and proceeded to where the woman was. He carried her to the next floor below

when he was nearly overcome by the smoke and had to drop her to save himself. James Rossiter had reached him at this time and he carried the woman from the burning building. The woman was nearly suffocated by the smoke, but she rallied after reaching the air so that she was able to go to her home. Neither Mr. Hanson or Mr. Rossiter knew the name of the woman that they had rescued.

Thomas Leavitt was early on the scene and he did good work in assisting to save people from the burning mill. Mr. Leavitt and Wesley B. Stirling, driver of the Hook and Ladder truck, and some other men ran a ladder up to the windows of the east end of the mill and rescued several people. While they were attempting to put the ladder up a man who was standing near them refused to assist them in the work and he did not give any reason for his refusal. Had he taken hold of the ladder with the men the work of running it up could have been done much more quickly and easier. It is said that the man was a member of the fire department but we hope that this part of the story is not true. If it is true he should be dismissed from the service at once.

John Hester of No. 7 Sonnet street was among those that were injured in making their escape from the fire. He slid down the rope from the fourth story, and the rope burned his hands so severely that he was obliged to let go his hold and he fell quite a distance to the ground where he severely injured one ankle. He was assisted to his home on Sonnet street where he had his injuries attended to by Dr. Young.

Harris McGlone of No. 9 Sonnet street was badly shaken up by dropping from the fifth story. He hung from a sill of a window and dropped to the ground. Miraculous to relate no bones were broken. He was taken to his home and attended by Dr. Young.

A Greek who was very thinly clad and who had made his escape from the burning building by sliding down a rope, appeared at the police station at about 8:30 o'clock with the blood flowing freely from the injuries to his hands and he was suffering intense pain. James McCabe, clerk of police court, who was at the station when the man called, accompanied him to the office of City Physician John D. O'Doherty where he had his injuries dressed. The man's hands were burned and lacerated in a terrible manner. It was impossible to learn his name as he could only talk a very little English.

At 7:15 o'clock after the fire had been raging about three-quarters of an hour, ex-Alderman James N. Whelan discovered four men with their heads out of the window on the back side of the mill on the fifth floor. He at once recognized one of the men as James Connors, and he quickly gave the alarm that there were four men in the building who were holding their heads out

of the window to prevent being suffocated. Mr. Connors was shouting for help and said to the crowd below "For God's sake put up a ladder so that we can escape for we cannot live here another ten minutes." The crowd below shouted to the men to go to the window on the end of the building, that there was a rope there. The men however did not make any attempt to leave the windows. They evidently could not hear what was said to them or else they could not leave the window on account of the smoke in the inside of the room. The firemen then set to work to get a ladder up to the window to rescue the men. The first ladder that was run up was not long enough by at least twenty feet. The firemen then got another extension ladder but that was not long enough by a dozen feet and an attempt was made to raise the ladder at the bottom so as to put a large box under but this came near resulting disastrously, and it was by the smallest margin that the ladder was saved from falling and being smashed to pieces.

[Text obscured] did a most daring and heroic piece of work in rescuing the men. He went to the top of the ladder with a rope and then pulled the pole up. He lashed one end of the pole to the ladder while Connors, who was up in the window waiting to be rescued lashed the other end to the window sill, making the rope fast on the inside. This made a way for the men to escape. Connors was very cool for a man that had passed through the experience that he had, and he lashed his end of the pole with the air of a veteran. After all was made fast Lieut. Bradley remained at the top of the ladder where the pole had been lashed, and received the men as they slid down to him, doing the most daring ladder work that has ever been seen in this city. Capt. John McDonough also did good work on the ladder in rescuing the men from their perilous position. Joe Doeris was the first man to slide down the pole to the ladder and he quickly came down the ladder to the ground. He was barefooted and his pants were nearly tore from his body. He was without coat and as soon as he reached the bottom of the ladder he was quickly received by a dozen hands and blankets were wrapped about him and he was taken home. James Connors was the next man to come down and he made the descent very quickly. He had his overcoat on and was the best clad of the quartette. The third man to come down was a french Canadian whose name it was impossible to learn. Harris McGlone was the fourth one to leave the room, but the young French fellow when about half way down the ladder, swung to the underside and passed McGlone and came down hand over hand without touching his feet to the rounds of the ladder. He was very thinly clad and was barefooted as was McGlone. Each of the men was rolled up in blankets and quickly taken to his home.

Previous to the putting up of the ladders a large number of the employees of the mills with the mill teams hauled cotton and bagging which was piled up around the mill under the windows where the men were so in case that they had to jump before ladders could be run up that they would alight on the cotton and bagging and possibly save themselves from injury.

James Connors was seen by a Democrat representative as soon as he reached the ground from his perilous position and he said his experience was the most terrible that he ever passed through. When asked if he thought that all the operatives had made their escape from the building he said that he feared that some had lost their lives by being suffocated by the smoke which he said nearly overcame him before he could reach the window where he was discovered by ex-Alderman Whelan. Mr. Connors said he was pretty certain that people were lying along on the floor in the fifth story of the building. He felt bad to think that he was unable to assist them, but he only escaped with his life by the smallest possible margin. The experience which Mr. Connors passed through was a strain upon his nervous system and the half-hour that was spent by the firemen in trying to get the ladder up must have appeared ages to him and his companions.

The second hand of the weave room who has only recently assumed the duties of the position and whose name it was impossible to learn, during the excitement of this fire was found in an unconscious condition, having been overcome by the smoke. He was rescued by John McCoole and taken out into the air where he quickly recovered so as to be able to be taken to his boarding house.

All kinds of stories were afloat as to how the fire originated and that is a matter that at present seems to be a mystery but there is one story that looks quite probable. It is said that the fire might have originated from an electrical spark on the large main belt, which operates the machinery on the top of the building.

A woman that was employed in the weave room on the second floor says that she saw something which looked like a spark on the big main belt which carries the machinery on the floors over the weave room, and that when the belt passed through the box on the floor the box ignited. She saw a flash and in an instant she says the room all around where the belt was, was in flames which spread very rapidly to other sections of the room. The belt was only a short distance from her work and when she saw the flames spreading so rapidly she quickly made her way to the stairs and got out of the building.

Another report was largely circulated that the fire originated from a hot box in the engine room, the fire being carried by the main belt up through the

building to the rooms where the cotton and lint was ignited which caused the flames to spread over the building, but this does not look probable as there was no fire in the lower stories of the building, the fire when discovered, appearing from the outside to be all in the third story which is the carding department.

The firemen had a hard time at the fire, the weather being cold and where the water struck them it quickly froze to their clothing, making it difficult for them to move around and stop causing them suffering. Many of the firemen went to the fire without their breakfast but hot coffee and sandwiches were provided for them as soon as it was possible.

One woman who made her escape from the building during the early stages of the fire left her envelope containing her pay near her work, and she went back to the mill door to go in after her money but those on duty refused her admittance or she would probably have lost her life in search of her money.

It was fortunate that the wind was not blowing to any great extent at the time of the fire or the loss might have been much larger.

James Rossiter found a Greek on the stairway of the mill who was nearly suffocated with smoke and he assisted him to the open air. The fellow was very thinly clad and was barefooted. On reaching the open air he quickly recovered and before anyone could assist him he started on the run for his home which is said to have been on Payne street.

As soon as possible after the seriousness of the first fires learned Marshal McKone had Capt. Stevens and all of the night men on duty at the fire and they did good work in keeping the large crowd which had assembled at a safe distance and out of the way of the firemen.

No. 1 mill was erected by the Cocheco Manufacturing Company in 1877, at a cost of $640,000, and was one of the best constructed mills owned by the company. The mill was 400 feet in length, five stories high, with a basement. The mill employed about 450 or 500 operatives who are now thrown out of employment which will fall heavily upon many of them. The machinery in the mill is estimated to have cost a million dollars. A large number of new and improved carding machines were put in the building last summer, and many new and improved spinning frames have but recently been placed in position in the spinning department. The mill was finely equipped and the loss to the company will be a heavy one, but is probably well covered by insurance.

A story was circulated quite freely at the fire that one of the city teamsters who was early at the area of the fire went inside and attempted to rescue some of the operatives and it was said that he saved a person lying on the

floor of the mill and attempted to remove him [but] was unable to do so because of the denseness of the smoke which nearly suffocated him and he had to leave the person to his fate. A Democrat representative attempted to find the teamster and verify the story but he was unable to do so.

A canvass of the employees of the mill is being made to see if any and how many are missing.

John Doeris has been investigating to see if any Greeks who were employed in the mill are missing, and he has been unable to find any trace of Sonstantine Eleopupios and John Necolopuios who were employed in the mill. It is learned that they left home the morning for their work and it is thought that they have lost their lives in the building.

It is said that the young French Canadian, who was rescued from the fifth story window, was employed in the fourth story of the building and that when he saw the fire he went to the stairs and instead of going down that way he went up the stairs, to the top story. This story is told by a young man who was with him when he left the room and who came down the stairs and made his escape from the building in safety.

A young man by the name of Keenan, who was employed in the dressing room, had a narrow escape from being suffocated by the smoke but he managed to reach the window handle on the back of the mill and escaped, but not without some injury. He had one of his hands quite severely cut by glass or some other substance in getting out of the window.

The automatic sprinklers in all of the stories below the top story, where the fire was, worked perfectly, it is reported, and no doubt were the means that prevented the spread of the flames below where the destruction was almost complete.

At 2:20 o'clock, three bodies were taken from the ruins, and removed to Glidden's undertaking parlors and one body removed to Tasker & Chesley's, making four bodies in all.

All the bodies were thought to be those of boys as they were found in the mule room where the boys were employed. The bodies were all burned so badly that it was impossible to identify them.

A human foot was also found behind the mill this afternoon which from its size was thought to be that of a man. The foot was crushed and badly roasted.

Three boys are said to be missing, their last names being Hester, Cosgrove and Redden.

The fire was under control at about 2 o'clock and the firemen started to make a search of the ruins for bodies.

Two days later, on the twenty-eighth, the *Foster's Daily Democrat* reported that it thought that the flames had been put out but that they had been wrong. The fire had died down; however, it came back vengefully, spreading throughout the mill. Two of the six thought missing turned out to be alive, by God's good graces. The total death count had been five. In May 2006, library director Cathleen Beaudoin described it as a Hurricane Katrina–like situation for the people who worked in the mill and lived in Dover. Beaudoin, along with other librarians and participants from the local historical society, put together a show called *Factory on Fire!* It was a reenactment of the mill burnings and the resulting court case. It was meant to show the importance of how one community can bounce back from such a devastating blow. Jeremiah Rood interviewed the library director about the event for the *Fosters Daily Democrat*; some citizens were worried that the library had decided to actually set the building on fire.

"We're not really setting the mill on fire," said Beaudoin, hoping to quell concerns about smoke and asthma.

The show begins by having guests enter the early 1900s through a movie designed to set the scene. The production will include old photos and try to show what life in Dover was like in 1907.

The focus then turns to a David-versus-Goliath lawsuit between millworker William Turner and the mill owners. Attendees will get to view several reenactments of the trial, complete with its surprising ending.

Beaudoin said that they are not giving away what happened in the trial or what caused the fire, but as a hint, she said that the fire's cause involved water.

The show is based on years of work by Mark Leno, who conducted all of the research on the fire. Leno is a Dover police officer who has acted in all previous "Revealed" events.

Yes, water caused the fire at the Cocheco Mill No. 1. But how? Mark Leno, the man talked about in the article and the foremost historian on the Cocheco cotton mill fire, theorizes that it was because of the sprinkler system they had installed.

In an interview, he said that one of the sprinklers was malfunctioning and going off, so they shut off the water to prevent any further damage to the machinery but didn't mention it to anyone. Meanwhile, a big thirty-inch belt, which ran the mill, was getting wet and slipping. This was right above the carting room, where they stored all of the cotton. The belt kept sparking; it caught on to the cotton and resulted in the disaster.

The librarians and town clerks are familiar with paranormal investigators coming in to look up on the disaster. There are claims that if you sit in the

stairwell in either of the two towers you will hear faint noises and sometimes even whispering. There are reports of strange lights going on and off in the top two floors. In addition, while standing outside the building, you can hear machines turning on and off; if you wait a couple of minutes, you will hear a big bang of a machine starting. These are reports that were told to various paranormal investigators, although we cannot say for sure exactly what phenomena besides these do go on.

How to Get There

From the south merge onto I-95 North. Take Exit 4, NH-16 N, on left. Take Exit 9 toward Dover, New Hampshire/Somersworth/Dover. Merge onto Indian Brook Road. Continue onto High Street. Take a slight right onto Washington Street. The mills will be on your left.

From the north take NH 16 South. Take Exit 9 toward Dover, New Hampshire/Somersworth/Dover. Turn right onto Indian Brook Road. Continue onto High Street. Take a slight right onto Washington Street.

HILL: OLD HILL VILLAGE

Over the eleven years that Beckah and I have worked together as an investigative team, it has been our privilege to visit and learn about many different abandoned towns. Evidence has shown us that most were lost due to hardships encountered while farming (often due to a lack of nutrient-rich soil and a bit of raiding from nearby indigenous), as was the case with Monson Center in Hollis. What ended up happening was the men would go and find work in other townships nearby, leaving the women to fend for themselves while they were away—such was the case in Dogtown next to Gloucester, Massachusetts. These towns could not thrive. Hill, however, has a very different history. These people were *forced* to leave their village by Mother Nature and the U.S. Army Corps of Engineers.

In 1753, eighty-seven proprietors were given a territory of land; it was made up of what is now known as Bristol, Bridgewater, Hill and parts of Wilmot and Danbury. Some of the eighty-seven landowners decided not to settle in the area; instead they would go on to sell their tracts of land to people who wanted to live there. In 1767, two settlements were forged within the limits of what we now know as Hill Village—one by a man named Carr Huse and another by Captain Cutting Favour.

Favour decided to settle close to the Pemigewasset River, nearer to what is now known as Bristol, and Huse settled neatly into the town of Hill. At first, they decided not to stay at the settlements during the winter so they would not have to face harsh weather conditions and also because it would give the natives an easy target. By 1770, people in both settlements felt comfortable enough to stay on their land the whole year through. Some of the other eighty-seven had settled in the area, as well, although most would be outside the bounds of Hill Village. However, there was no name for their area. They were not considered a town or a village. They were just "that place." They had no real local government or town meetings. So the settlers got together to petition the courts for recognition as a township. They set forth their initial petition in 1774, but it was denied; finally they got their incorporation passed on November 20, 1778, and they became New Chester. Now the name was not wholly creative, as many of the settlers had come from Chester. However, it worked for the time being.

> *To the General Court of the State of New Hampshire:*
> *The Humble Petition of the Inhabitants of the Township of New Chester. Wee, the Inhabitants of S'd Township, Do Labour under Many Grievances and Disadvantages for Want of an Incorporation whereby wee might have officers indowed with Power, authority, and that wee might Lay out our highways So that wee Might make and Re-pair them So that travilers might Safely travel or pass through the Town Ship Safely, for want of which wee are Sensible; Some of your Honours are Sensibleof and many more Dificulties which wee Labour under; wee, therefore Humbly Pray your Honours to Grant us a Charter of Incorporation Investing us with the Powers, Priviledges and authorities as other Towns within the State Do Injoy, and your Humble Petitioners, as in Duty Bound, Shall Ever Pray.*
> *New Chester, October 15th, 1778.*
> *It is Desird that the Town May Be Incorperated By the name of New Chester.*
> *Carr Huse, Cutting favour, Chase fuller, Jonathan Crawford, thomas Lock, moses Worthen, Gideon Sleeper, John Russell, Jacob Wells, Tilton Bennet, John Kmery, Benjamin Emons, Simeon Cross, Samuel Worthen, Abner fellows, Theophilus Sanborn, John Cleveland, Nathaniel Sanborn, Eben' Ingalls, Josiah Heath, Jonathan Ingalls, Peter Sleeper, John Kidder.*

Unfortunately, the way that the town was formed geographically made it difficult for trade and other business transactions. So our settlers went

One of many cellar holes located in Old Hill Village.

back to the cartographer's drawing board. They outlined their difficulties to the state's general courts in 1787 with their bid to break up the town into smaller townships:

> *To the Honourable Senate and House of Representatives of said State, to be convened at Charlestown on the Second Wednesday of September, A.D. 1787.*
>
> *The Petition of the inhabitants of New Chester, in said State, Humbly Sheweth, Wee, your Petitioners, Labouring under many Difficulties and disadvantages in our present Circumstances by Reason of the Town Being Exceedingly Long and in one place but a very little more than one mile wide, which makes it very Difficult for the Major part of the people to attend Public Worship, when we have preaching in Town and like wise to Attend Town Meeting, as it is Commonly bad traveling when wee have our Annual Meeting, the Town is more than Nineteen miles in Length. Wee, your Humble Petitioners, Earnestly Request that your Excellency and Honours would*

Divide the Town of New Chester into two Towns, and that it may be Divided at Newfound River, So Called (vs.), Begining at the mouth of Newfound River, running up said river untill it comes to Newfound pond; then running on the easterly Shore of said pond untill it comes to the Town line between New-Chester and Plymouth, and your petitioners, as in Duty Bound, will ever Pray. New Chester, August 23, 1787.

Carr Huse, Reuben Wells, John Russell, Nathan Colby, Peter heath, Jonathan Ingalls, Jun., Elias Boardman, Jon Ingalls, Nathaniel Sanborn, Eph» Webster, Cutting favour, Michael Mosher, Thomas Huse, John fellows, Jonathan Holt, Josiah Brown, David Emerson, Thomas Rowell, Joseph Johnson, Thomas Locke, Samuel wortlien, Benja Boardman, John Mitchel, Jacob Fellows, Joseph JIarshall, Joseph Em- ons, Moses Fellows, Simeon Cross, Daniel Heath. James heath, Jonathan heath, David powell, Alexander Craig, Jonathan Carlton, Ephraini Clark, John Mitchell, Jun,' Ziba Townsend, Chase Fuller, Johu Ladd, Samuel Drew, David Craig, Robert Craige, Seth Spencer, Isaac Senter, Jonathan Craivford, Benjamin Emone, Wilham Powell, Josiah heath, John heath, James Craige.*

It took more than seventy years to divide the land up completely; the northern part was the first to be incorporated and was named Bridgewater, later Bristol. Some other pieces of land were annexed along with nearby towns; such was the case with Wilmot, Hill and Alexandria. Hill's neighbors became Danbury to the north, New Hampton and Sanbornton to the east, Franklin and Andover to the south and Andover and Wilmot to the west. The estimated acreage of the village was about fifteen thousand, with a population of 667. I've talked about this setttlement before, and every time I do people ask me, "Why Hill?" Though it is located in one of the rockiest areas in central New Hampshire, Hill is actually located in a valley! However, it was not the scenery that inspired the name but rather the governor at the time, Isaac Hill. It took on that name in the 1830s.

The village itself had beautiful farmland. If you go there now during the summer, it is wild and overgrown, but you can still note the layouts of the different farms and the richness of the soil. Hill bred not just good cattle and crops but also raised good boys and girls. A few natives of the village went off to do wonderful things, such as Gilman Kimball, son of Ebenezer and Polly, born in 1804. Gilman went on to become a renowned surgeon. He created a method of amputating a leg at the hip, which previously was thought impossible without killing the patient. He traveled the world and eventually settled in Lowell, Massachusetts.

Prior to its incorporation, the settlers of New Chester had already decided that since they were so closely situated next to the Pemigewasset, Smith and Newfound Rivers, they were going to capitalize by creating sawmills and gristmills, the ruins of which can still be seen upon entering the old, abandoned town. When we went, I was particularly interested in those remnants. As you enter, you are walking directly parallel to the waterway, and about halfway down the path you can see large stone walls sticking out of the cliff that lead down to the river. You can even still see pipes, gears and other assorted large hardware. It really is a very interesting feature in this abandoned town. Hill may have made a legacy, but it was not to be as a mill town. It did, however, get a reputation for having the largest establishment for glasscutters in the world. However, Hill seemed to manufacture everything, from cloth to axe handles, and it really was a tiny hive of industry.

Citizens of Hill established schools and churches early on; the community grew, and although it was still small in comparison to today's towns and cities, the people thrived. They continued to do well for themselves. In 1773, Carr Huse created a cemetery on his tract of land "about forty rods from his house."

Part of the mills that run along the river.

Those of note who were interred within the cemetery included one soldier from the French and Indian War and another from the Revolutionary War. In 1845, the Ferrin Cemetery was opened to the public about a mile west of the town's meetinghouse. Bunker Hill Cemetery (now a part of Wilmot) harbors many of the residents of Hill.

But how did this plentiful community of God-fearing manufacturers and agriculturists turn into a ghost town in less than two hundred years? You could say that it happened nearly overnight.

The Pemigewasset River handled the snow melting from the White Mountains, and during springtime, flooding was common. In the spring of 1936, though, there was a record flood season. Between the melting snow flooding into the rivers and the ice jams that clogged up those same rivers, the flood didn't just affect the Lakes Region—it struck the whole of New Hampshire. This can be seen in the following news article, published about a city south of Hill—one that I know very well, because I live there. In Manchester, New Hampshire, the floods created complete devastation:

Manchester Leader and Evening Union, *Manchester, New Hampshire, March 20, 1936*
HEROIC POLICE, VOLUNTEERS SAVE 32 FROM DEATH IN PISCATAQUOG
Two Animal Trainers Trapped on Roof Snatched Just in Time and Groux Island Couple Has No Less Narrow Escape

One thrilling rescue after another, beginning last night and climaxed at noon today, took place along the banks of the raging Piscataquog river in West Manchester, until the lives of 32 men and women had been snatched from sure death by police and civilians.

Police at dawn enacted a movie thriller as they rescued Mr. and Mrs. Antonio Kemes of Cleveland street as they clung to the roof of their Groux's island home in a last desperate effort to hang on.

Early this morning, two animal trainers, who handle the zoo family on Second street, became stranded on the zoo roof, and were rescued only after a desperate five hour battle with the currents by police and neighbors.

Shortly before noon, the two men, Capt. V.H. Walker, trainer, and his assistant, Boyd Arquette, both of 39 Winter street, jumped from their rooftop perch into a waiting boat and one at a time were landed on the "shore," then located at Blaine and Second streets.

For close to five hours the men had been pacing back and forth on the roof, partly nervousness and partly to keep warm, as the branches of the

raging Piscataquog continued to climb the sides of the building, and water, floating ice cakes and general debris battered the walls and kept the structure constantly a tremble.

Police Work Hours.

Inspectors Walter C. Suosso and Joseph Pouliot had made a series of desperate efforts to reach the stranded men by the down current route, had come close and barely escaped with their lives, and were on another desperate dash, when two local men, battling the river from the lower route, suddenly smacked the boat against the tottering temporary zoo.

Jules Chapdelaine and Arthur Carreau of 50 Cleveland street were the boat's pilots. Keeping cool and counting every move carefully they foresaw the danger of overloading the small craft and ordered the men to come down singly. Captain Walker was the first rescued, after he had jumped down two shed roofs and was shortly on "shore." With the smile of victory on their faces Chapdelaine and Carreau, then sure of their route, heroically dashed back to the zoo and shortly had Arquette too, on land.

Worry Over Animals.

The rescued men were taken by police to the office of the Manchester Dairy System, Second street, where the office girls soon had hot coffee ready and made their guests comfortable otherwise. Captain Walker, interviewed by a Leader reporter, said he and his pal had worked all night in a desperate effort to save the lives of the animals and in doing so found themselves in turn imprisoned by the flood.

They helped each other to the rooftop at 7:30 this morning and for the next four and a half hours paced about the roof. As the water rose, other buildings in the area gave way, their own perch trembled and they figured it only a matter of time when they would go careening down the river atop the building, heading for sure death.

Both men expressed deep grief over the probable fate of their animals. All night they had worked to save them. Monkeys and other small specimens had been brought across the road to a building then considered safer.

Two bears and two leopards were lifted bodily by the trainers early this morning to the tops of their cages, here they are loose at the present time, but safe from the flood. In the building are four bears, two leopards, four ponies, elk, buffalo, three lions, four coyotes and other animals, many of which probably drowned. Captain Walker said at noon, however, that sounds from below led him to believe that many are still alive.

Water Still Rising.

With the Piscataquog's water rising constantly and the situation getting more dangerous hourly, every policeman in the city was called to duty, working all night while the city generally slept soundly, unaware of the flood dangers.

Deputy Police Chief James F. O'Neil personally directed the rescue of an aged couple from Groux Island and more than 30 people residing on Wentworth street along the Merrimack.

The sensational tale of heroism on the part of Inspectors Walter Suosso and Joseph Pouliot and Lt. Walter Guiney was told at headquarters this noon as Deputy O'Neil related how the men had rescued the marooned Mr. and Mrs. Antonio Kemes of Centennial street. Both about 60 years old, were found on the roof of their home on the island. A previous attempt to rescue them late last night had failed but at dawn today, the police were back on the scene.

Caught In Air.

Inspector Suosso made the woman and man lie flat on their backs on the roof and told the woman to slide down. She dropped 10 feet and he caught here [sic] in his arms, balancing himself in the boat which threatened to capsize on more than one occasion. The same procedure was used to rescue the man, the big husky inspector succeeding in catching both persons.

Not satisfied with this work, Inspector Suosso did his share of the rowing back to land. Inspector George Welch and Thomas Armstrong waded waist deep half a mile to help rescue people on Westworth avenue. Included in the group were eight children, a sick woman and a man crippled by injuries. Two trucks of the Highway Department were of invaluable service to the officers.

Inspector Thomas D. Kelley and Sgts. Romeo Harbour and Thomas Austin were other officers who did yeoman service last night and this morning.

Police Marooned.

Inspectors Welch and Armstrong became marooned in Amoskeag last night when they came upon a washout big enough to hold a house. The station, through radio, gave the men instructions and they were finally able to make their way to this city.

"The radio has paid for itself since last night" Deputy O'Neil said today. All police officials were of the same opinion and it was stated that

the police never would have been able to accomplish what they did without the aid of the shortwave system.

From an early hour last night, police were warning residents along the Merrimack and Piscataquog rivers to flee their homes.

About an hour before police attempted to rescue the Kemas, Sgts. Mortimer Shea and Harbour succeeded in rescuing another family living on Groux Island. Mr. and Mrs. Michael Leinsing of Christopher street.

Local police sped to Goffs Falls this afternoon answering an urgent call from the Elms where Mr. Coldwell, injured sometime ago in a skiing accident, was marooned in the house and in danger.

Manchester Leader and Evening Union, *Manchester, New Hampshire, March 20, 1936*
BEAR ON ICE CAKE, TWO LEOPARDS CLING TO MENAGERIE ROOF

Two hundred animals of the Manchester zoo have perished in the flood waters of the Piscataquog but three remain alive and are facing certain doom.

The three are a pet bear and two leopards. The bear is on a cake of ice, jammed against one of the flooded buildings in that vicinity while the

Where the town bridge used to be located.

leopards are on the roof of the zoo crouching in fear and terror. The animals will either drown or die of starvation as access to them is impossible.

Leandre Charbonneau owner of the zoo was refused permission to make an attempt to save them. To do so would bring almost certain death to himself, he was informed.

Across not just New Hampshire but all of New England, the damage amounted to $113 million, with twenty-four people dead and seventy-seven thousand homeless. It also left Hooksett, New Hampshire, under about twenty feet of water. The Army Corps of Engineers proposed building a flood dam a few miles south of Hill to help control the waters and prevent another disaster. The federal government offered to buy their properties so that the residents could move on to other towns. However, the government forgot that Hill was a town of inventive and determined people. Instead, citizens formed a committee of residents and applied to move the town a little over a mile out of harm's way. The government agreed to this and paid to have the buildings moved. Construction started in 1940, and by June 1941 the new town hall and school were completed, fourteen buildings were moved and a water system was put in, as well as streets and thirty houses. Not too bad for a year's work; in 1941, they held their last meeting in the old town hall, recessed part-way through and reconvened in the new one.

Katie and I decided to go over to the Old Village on a hot summer day. We do not recommend that. Needless to say, we were the only ones there. Many believe that paranormal researchers investigate at night because that is when the activity is at its highest, but this is not the case. It is to control the environment at night, and it makes it easier for us to rule out possible contaminations. That being said, we figured that the place would be abandoned; it was the middle of the week on a hot June day. The paths were made from dirt that had been baking in the sun and seemed more like a fine dust or sand. We got there about two o'clock in the afternoon, brought our still camera, video camera and audio recorder.

There were two things that we, as city girls, did not realize: firstly, the closest Dunkin' Donuts was about three miles away; secondly, that there were so many bugs. I met my first horsefly that day and gazed into its beady red eyes as it bit into my flesh…what fun. Nevertheless, the village was a serene area, with markers set to show where the different buildings used to be located. I honestly did not notice much psychically while we were there. The few things I did receive included a sense of bustle on the main roads and, at one of the farm fields, a light singing. You did get the sense of being

watched while there, but whether that was the spirits or the bugs I cannot say. Unfortunately, we did not get much in the way of evidence, but Hill is a beautiful place to go. I encourage it, but please visit closer to autumn, when the heat has died down and the bugs have vacated.

How to Get There

It is located off Route 4 in Hill. Next to the post office, take the dirt road to the old site of the former Hill town location.

PART III
THE POOR AND THE MENTALLY ILL

STRAFFORD COUNTY POORHOUSE

Poor farm families would often take "delinquents" into their homes and feed and clothe them. The creation of poor farms were common in the 1800s in response to an increase in the pauper population. Each town gave or bought land in their area (typically a farm), created housing for these poor souls and then appointed a husband and wife as heads of the establishment. This married couple was responsible for running the various aspects of the farm, including handling crops, accounting and so on. The state paid salaries and expenditures not covered by the profit from crops and dairy sales. However, many towns became exasperated with the idea of these farms looming on the outskirts, so they began to force these individuals into the responsibility of the county. Strafford County soon realized that town farms just did not work and felt that it had to create its own refuge for the poor. Officials also found out while planning their own asylum that it happened to be more logical financially to handle things in this manner. Each town charged outrageously for the inmates it kept.

In 1866, the Commission for Strafford County went ahead with the changes, and in the process it bought the John Trickey farm on the north side of the Cocheco River in Dover, about four miles away from city hall. The county took control of the property on May 21 of that year and installed Mr. and Mrs. Caswell to live on the property as director and caretakers. The farm was 165 acres total, 90 of which comprised a field that year after year produced magnificent crops. Not long after establishing this first farm, the

commission decided to expand it by buying the Timothy Snell farm, which adjoined the northernmost part of the property.

The couple in charge of taking care of the county poor up until that time lived in a quaint farmhouse on the property. However, with the inclusion of this new piece of land, a beautiful brick building was constructed in order to house the superintendent's family and the poor. Within two years of the farm having started, most of the towns within the county had sold their own poor farms and sent their paupers to Dover.

The county poor farm had to answer to someone, and so it created annual reports estimating the value of the property, and things located there in the financial tally came to a whopping $43,144.80. It was ascertained that some of the inmates kept at the almshouse were in all actuality mentally unstable; these inmates would be sent to the state asylum in Concord—for $5.00 per week, the hospital would board the inmates. The commissioners for the Strafford County facility decided that it would behoove them to create their own safe haven for the incurably insane. On the Snell farm was a building that they decided to fix up specifically for that purpose. Mr. and Mrs. Caswell continued to manage the farm, and the county hired an assistant for the family to manage the asylum. During that time, they expanded the facilities for the insane.

All went along smoothly with no complaints regarding Mr. Caswell's abilities to manage nor the abilities of his assistant. Mr. Caswell died in 1880, ending his reign as superintendent. Over the next two years, two more families would take his place without incident. In 1890, the county hired Charles Demeritt and another who would act as his assistant, named Mr. Driscoll; for the first three years, things ran smoothly. Nevertheless, Mr. Demeritt and his assistant truly did not agree on much, and permission was granted for Mr. Driscoll to have full reign over the insane asylum. The Driscoll family moved into a small apartment there, and the only thing they were not responsible for was the clothing. Just prior to the winter of 1893, Driscoll and his wife started to have bad feelings; they just could not shake them, no matter how much they tried. I'm pretty big on intuition; I wish they had listened to theirs.

Demeritt had given up all attachments and control of the insane asylum on the Snell farm, so to whom would Driscoll have reported these nasty feelings? Would the commission do something based on a feeling of bad vibes, or would the members think that maybe some of the insanity was rubbing off? Maybe if there had not been so many issues between Driscoll and Demeritt the tragedy that followed the nasty feeling would not have happened:

The Poor and the Mentally Ill

Bangor Daily Whig and Courier, *Bangor, Maine, February 11, 1893*
Stratford County Insane Asylum Fire
February 10, 1893
THE ASYLUM FIRE.
Where the Watchman First Discovered the Blaze.
Everything Done to Rescue the Helpless Inmates.
Only Three of the Forty-Six Escaped.

Dover, N.H. Feb. 10. With regard to last night's holocaust, Watchman Wilbur Chesley says that while making his ten o'clock rounds he discovered fire in the cell occupied by Mrs. Lafountaine, at the foot of the bed. He pulled the woman out of the room and closed the door. He called Keeper Driscoll, who helped break the locks and gave a general alarm. The Lafountaine woman and Frank Dauchenue ran out into the yard. The fire ran rapidly through the building as if it were saturated with oil. There was no way of getting the insane people out. Chesley himself had to run through a sheet of flame to get to the outside door. He could do nothing to save the asylum.

Keeper Driscoll, who lived in the building, says he ran from his room, in his night clothes and did all he possibly could to get out the inmates. His hands were badly burned. He had to break through a double window from the outside to rescue his wife and children, clad only in their night clothes.

Driscoll says there were forty-six inmates in the cells and only three escaped. Carpenters had been doing some work at the asylum, but it is not known that the Lafountaine woman got any of the shavings. She made her way by some means to the yard, which was surrounded by a high close fence, and must have been roasted alive.

Dauchenue managed to climb a fence and was saved. Charles Demeritt, superintendent of the farm and alms house, says he was awakened by the watchman. There were ninety paupers in the alms house, and forty of them were women, in the wing next to the asylum. He got them all into the other wing and the men done good work with water in pails and saved the main brick building.

Coroner Daniels, of Rochester, began an inquest at one o'clock to-day. The scene is five miles from this city over one of the worst roads ever traveled. The body of Mary Roberts, of Great Falls, has been identified. People for miles around visited the scene.

The ruins of the Strafford county insane asylum present a gruesome spectacle today. People are driving in for miles around to view the charred and blackened ruins. The burned building was of the ordinary wooden type, and was a veritable tinder box. There is no effectual fire protection

within four miles. The insane were locked in cells, and as usual in such institutions the great majority were chronic cases. Mary Lafountaine, a French woman from Great Falls, who had been afflicted with melancholia, became so violent recently as to be absolutely dangerous, and was locked up in a small room by herself. She had not been let out for two days. The keeper found this woman in the mad enjoyment of a blazing fire increasing every moment in energy, and in its scope. How it was kindled cannot be known for Mary La Fountaine has been carefully searched, and was allowed neither matches nor lamp. The only means of protection were fire pails set in quartettes along the corridors. Each bucket was filled to the brim with water. There was no force pump, and the nearest efficient fire apparatus was four miles off by the lonely ice bound road.

There were upwards of forty-eight persons, a third of whom were under lock and key, at the mercy of the fire with which this mad woman was so recklessly frolicking.

Mr. Driscoll was prompt to act. "The fire," said he, "seemed at first no bigger than my hand. I dashed the contents of the nearest four pails of water upon it and then ran for the cells to release the other insane people."

The keeper succeeded in opening fifteen cell doors before he was obliged to fly for his life and escape by jumping from a window. The flames rushed through the corridors, the length of the building, 135 feet, and the smoke enveloped the stairs. There was no escape except by the windows. The lunatics on the second floor soon became frenzied. They laughed sang and shouted by turns, while some sat stupefied, and gazed with summary melancholy pleasure upon the approaching flames. The building soon became a furnace of fire.

In Decatur, Illinois, there was also a report of the fire, although they did not know how the fire started.

Daily Review, *Decatur, Illinois, February 11, 1893*
SIMPLY HORRIBLE.
The Strafford County, N.H., Insane Asylum Burned
AND FORTY-FOUR PATIENTS CREMATED
The Poor House With Its More Than One Hundred Inmates Saved by Heroic Efforts—List of the Lost and Saved.

Dover, NH, Feb. 10—The county asylum, four miles from here was burned last night and forty-four lives were lost. When Watchman William Chevey

made his 10 o'clock trip into the insane asylum, he found fire coming out of the cell occupied by A. Lafamitain, a woman, and gave the alarm.

William Driscoll the keeper, with his family, lived in the building, and he at once broke the locks off the fifty-four cells and tried to get the inmates out, then he got his wife and two children, neither of whom were dressed.

Of the forty-eight inmates only four escaped. They are William Twombley, Rose Sanderson, William Davey and Frank Donshon. The latter walked two miles in a blinding snow-storm, with only his shirt on, to William Hoene's house, where he was taken care of. Those who were burned were

> ROBERT DOLNE, *of Salem Falls, NH.*
> MARY FOUNTAIN, *of Great Falls*
> FRANK NUTTER *of Rochester*
> WILLIAM CHESLEY, *of Durham*
> MRS. ROBERTS, *of Great Falls, and an 18 year old child*
> LESTER JONES *of Farmington*
> WILLIAM TWOMBLEY, *of Barrington*
> OWEN MALLEY, *of Great Falls*
> MICHAEL CASEY, *of Dover*
> FRANK ROW, *of Great Falls*
> CHARLES LIBBY *of Great Falls*
> FRANK PAGE, *of Rochester*
> WILLIAM FILES, *of Great Falls*
> FRANK SPR[?]GG[?]NS, *of Dover*
> HARRY KIMBALL, *of Dover*
> JULIA REED, *of Dover*
> MRS. MAAY LAVIN *of Salmon Falls*
> MRS. MARY MCCLINTOCK *of Dover*
> MAGGIE WHITE, *of Great Falls*
> ANN CARR *of Hollingford*
> MARY NUTTER, *of Rochester*
> MARY MALONEY *of Dover*
> LENNA ELLIS, *of Rochester*
> MARY WILSON, *of Lee*
> MARY TWINDALL, *of Milton Mills*
> CAROLINE RANT, *of Dover*
> MRS. ANN ROTHWELL, *of Dover*
> LIZZIE ELLIS, *of Great Falls*
> CATHERINE HA[?]EY *of Dover*

ELIZABETH PICKERING of Gonic
MARY COGGLEY, of Dover
SARAH SW[ET?]T, of Rochester
SARAH HUTCHINSON, of Dover
KATE DUFFEE, of Dover
SARAH McCLINTOCK, of Great Falls
FANNIE SLATTERY of Great Falls
ANN McDERMOTT, of Dover
ADDIE OTIS, of Great Fall
And six others whose names could not be remembered by the keeper, whose books were burned in the building.

The building was of wood, 31x36 feet, two stories high, with a big yard on each side. It was built twenty years ago, and had fifty cells.

One woman escaped to the yard, but was burned to death there. The building cost $15,000. The main building, in which were over 100 of the county poor, caught fire, but was saved by the heroic efforts of the inmates, who carried pails of water and extinguished the flames, although many were burned in so doing.

The Dover fire-department was summoned, but owing to the distance, the blinding snow-storm and the icy roads it took ninety-five minutes for the department to get there—too late to be of any service.

The smoking ruins show the charred bodies still lying on their beds. How the building caught fire is a mystery.

The fire was so extreme that it was actually mentioned in the *New York Times*, as well as in the *British Journal of Medicine* on February 18, 1893:

THE lunatic asylum of the Strafford County Workhouse, situated about three miles from Dover, New Hampshire, was destroyed by fire on February 9th. It is estimated that fifty of the inmates were burnt to death. The building, which was of wood and slightly built, was two storeys high, and covered an area of 130 feet by 35 feet.

There are several different accounts of the fire; unfortunately, there are no common numbers as to how many inmates, in fact, died from the fire. The names listed above are the most complete list in any of the papers; that being said, they do not all match up to the stone monument that is there now.

The New Hampshire Board of Health visited the site almost immediately after it burned down; with all of the press that this calamity created, it

wanted to get to the root of the problems quickly. It talked to the Driscolls, Mr. and Mrs. Demeritt and the night watchman Mr. Wilber Chesley, as well as other witnesses. Here is what they found:

The original structure was a two-story L shaped building with an attic, the first floor was occupied by the Driscoll's and seventeen inmates, the second floor was occupied by twenty-three inmates and the attic by another twelve.

There was a night watchman, Wilber Chesley, who received his orders solely from Mr. Demeritt, superintendent of the almshouse, and who was required to make six rounds each night, one of the stations, No. 4, being in the asylum of the insane. In making his 10 o'clock round on the night of February 9, he saw upon entering the storm door at the main entrance to the asylum, through the glass of the inside door, a reflection from the fire in the cell of Mary La Fontaine. He entered the asylum as quickly as possible, and rushed to the apartment occupied by Mr. Driscoll and family at the further end of the corridor in the L and informed him of the fire. Without waiting to dress, Keeper Driscoll rushed to the cell occupied by Mary La Fontaine and unlocked it, then turned and unlocked the cell of Jim Daly, nearby, telling the watchman to "get some water and open the doors"; but while getting Daly out, Mrs. La Fontaine jumped upon Mr. Driscoll's back. Driscoll almost instantly disengaged himself from her, as he states himself, and the watchman also testified that Driscoll had freed himself from the woman before he (the watchman) had got the front door unlocked. The watchman (Chesley) left the building as soon as possible, and the spring lock effectually closed the door after him and could not be opened from the inside. Driscoll proceeded to unlock the other cells and succeeded with those upon the first floor, barely escaping from the building in season to save himself and family. By this time, owing to the combustible nature of the building, it was thoroughly on fire so that further efforts to subdue the flames were unavailable. Two of the inmates whose rooms were unlocked by Mr. Driscoll escaped from the burning building, and the one woman was rescued from the second story from outside. The remaining forty-one inmates were cremated.

After giving a summary of the testimony of each witness, the board says: The board has carefully reviewed all the evidence presented in this case, and has arrived at the following conclusions:

First. That the fire originated in the room occupied by Mary La Fontaine, and was probably ignited with a match in her possession. It was known that matches were furnished those inmates who smoked. She

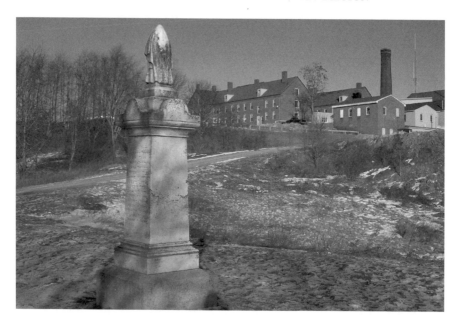

The monument for those lost in Strafford County Asylum fire of 1893. *Courtesy of Dave Bedard.*

smoked occasionally, therefore it would not be difficult for her to obtain matches herself or from other inmates. That the attendant of the asylum, William P. Driscoll, in a manner inexcusably careless, furnished matches to the afore-said inmates when called for.

Second. That the fire might have been extinguished immediately after its discovery had the watchman, Mr. Chesley, and the keeper, Mr. Driscoll, promptly made the attempt, inasmuch as at the time of its discovery the fire was small, being, according to Mr. Driscoll's testimony, "no larger than a bushel basket," and there was a fire hose ready for instant use, within a few feet of the fire, which was not used at all.

Third. That Mr. Chesley, upon his own testimony, is shown to be totally unfit for a watchman, by reason of his defective eyesight, and also in not knowing, after having made the rounds of the institution for several months, that there was a fire hose and fire buckets in the asylum.

Fourth. That the superintendent, Charles E. Demeritt, while having many commendable qualities, was inefficient in his administration of the affairs of the institution in the following particulars: Neglect in not having given specific instructions to his employees (and especially the watchman) as to what should be done in case a fire was discovered; in not disciplining,

or reprimanding the watchman for failure to perform his required duties, as shown by the register dial of the watchman's clock; in not having a properly organized and drilled fire squad, consisting of his employees and such inmates as might be available.

Fifth. That the attendant, William P. Driscoll, was guilty of faulty management in not having instructed the watchman regarding the means available for extinguishing fire at the asylum, even though the testimony shows that he had no authority over the watchman.

Sixth. That the county commissioners were negligent of their duties in the following particulars: In not giving explicit instructions as to the management of the institution, both the almshouse and the asylum; in not examining carefully and fully into all the details of the management of both these departments, and remedying the defects that might have been readily ascertained by them; in not providing fire escapes, which they might have done, to a greater or less extent, without a special appropriation for that purpose; in not furnishing suitable means for promptly liberating the inmates from their cells, the testimony showing that several different keys were required to unlock the doors; in dividing the responsibility of the management of the institution on account of personal differences between Mr. Demeritt and Mr. Driscoll, instead of discharging one or both, and employing one competent man to take their places.

Seventh. That prior boards of county commissioners were guilty of official negligence in not recommending to the county delegation such improvements and changes as were necessary to the best interests of the institution, and for not taking action themselves as far as their authority extended under the law.

Eighth. That all previous county delegations have been guilty of allowing to exist, and of maintaining, after having been officially warned of its condition in 1883, a building for the use of insane which was totally unfit for the purpose, and at which has existed at all times the terrible danger from fire, which finally destroyed it, with appalling loss of life.

Ninth. In investigating the rumors of intoxication connected with the institution, the board found that Mr. Demeritt has, for a short period, been addicted to the use of chloral; and that, in consequence of the use of that drug, his efficiency was, perhaps, somewhat impaired—but this had no bearing upon the question of the fire; that, so far as Mr. Driscoll was concerned, it appears from his own testimony and that of others, that several times within a year he has been given to the excessive use of intoxicating liquor, and on one occasion, at least, was gone from the institution two and a half or three days, leaving nobody, except his wife, in charge of the

asylum during that time. There was no evidence showing that he ever drank at the institution. The evidence further shows that two of the employees of the institution had been seen in a condition of partial intoxication.

The above were the conclusions reached from the investigation by the New Hampshire Board of Health. That system for caring for the county insane was the same in all counties, differing only in some minor details.

This was the county's failed attempt to fill a need. Since that winter of 1893, there had been no further such afflicted people brought to the almshouse or any of its buildings. Instead, they went straight to the state asylum; still they had other things to deal with, and instead of the insane, the farm now kept the drunks of the town. These drunkards were sent from the courts to the "house of corrections" on the farm; the county decided that they could work off their costs by farming the land. However, it seemed that there was not much behavior correction in this particular correctional facility, as many of the drunks became regular visitors to the farm.

Could the spirits of these poor fire victims still be there? Could the souls of the insane still be running around on the property, trying to escape the blaze?

You can go and find out for yourself. Dover has created the County Farm Cocheco River Loop Trail. It is a one-mile loop trail that consists of 212 acres of land. Wildlife is often seen there, and it is a beautiful walk or place to run.

How to Get There

Take Sixth Street out of Dover past Liberty Mutual. Turn left on County Farm Cross Road. Follow County Farm Cross Road a couple of miles to the jail/nursing home complex and park on the north side of the Riverside Rest Home parking lot. The trail starts at the sign here. Additional parking is located behind Riverside Rest Home. To park here, follow George Day Drive and turn right just before the Canoe Launch. (*Dover Community Trail Guide Pamphlet*, Open Lands Committee, Dover Planning Department, 2008.)

Or you can go directly to the site by taking County Farm Road. If you have a GPS, the cross street would be County Farm Cross Road. The jail, courthouse, Hyde House, Covered Bridge Manor and the Riverside Rest Home are located where the asylum and almshouse used to sit. You can still make out where the farms used to be, although there are no longer any signs

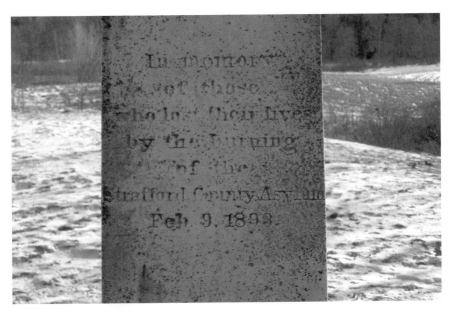

A close-up of the inscription on the monument. *Courtesy of Dave Bedard.*

of the asylum itself, except for a memorial marker that was placed. The inscription reads:

> *In memory of those who lost their lives*
> *by the burning of the Strafford County Asylum*
> *Feb. 9, 1893*

To get to the marker, head southwest on County Farm Road toward Corner Stone Drive. Continue on to County Farm Road for another 240 feet. Then turn right and follow for 0.2 miles, and you have reached the memorial marker.

LACONIA STATE SCHOOL (LACONIA STATE PRISON)

There is a reason why this section is located directly after the Strafford County poorhouse story; because of the incident there, pressure began to mount for change. In particular, people wanted to institute change for the children in the almshouses. In 1895, there were about 420 children in the poorhouses across the state:

The following document was submitted to the House of Representatives by representatives of the Federation of Women's Clubs on February 14, 1901. Introduced by Chuttes Littleton, it was referred to the Committee on Education for action.

The law of New Hampshire require that every parent or guardian of any child of schoolage "shall cause such child to attend school twelve weeks each year, six of which shall be consecutive, unless such child shall be excused from attendance by the school committee of the town or the board of education of such district, upon its being shown that the physical or mental condition of such child was such as to prevent his attendance at school for the period required..." Chap. XCI, Sec. 14

Provision is made for the proper education of the normal child, but for the deficient child against whom the doors of the public schools are necessarily closed no opportunity is offered whereby the dwarfed and latent mental faculties, its unhappy birthright, may be awakened and trained, as scientific investigation has conclusively demonstrated may be done. The State indeed recognizes that it has an obligation to this deficient class, of whom there are in the state of New Hampshire today according to the best statistics obtainable, about 256, for annually one-thousand dollars has been appropriated since 1879 to care for three of these children at the Massachusetts School and Home for the Feeble-Minded.

As a simple act of justice, is it right for the State, the guardian and protector of all its citizens—its children—to discriminate wholly in favor of those who are well endowed, and cast off those, who through no fault of theirs, are lacking in mental equipment? Furthermore, as an act of self-protection, is it not the part of wisdom to guard society from the crimes, the vice, and the immorality of this degenerate class, who with their weak will power and deficient judgment are easily influenced by evil? "As a matter of mere economy," so states a modern authority, "it is believed that is it better and cheaper for the community to assume permanent care of this class before they have carried out a long and expensive career of crime." In view of these facts...We, the undersigned, members of the New Hampshire Federations of Women's Clubs, do most earnestly call the attention of the New Hampshire legislature now assembled to the great need in our state of a School and Home for the Feeble-Minded and do urgently request that your honorable body give the matter your careful consideration and make such appropriation as shall be necessary for such a school.

The Poor and the Mentally Ill

In 1903, the state opened the New Hampshire School for Feebleminded Children, with Dr. Charles Little as superintendent; the view at the time on the disabled, the idea behind the Laconia State School, was not simply to help these children but also to keep them away. Eugenics came into prominence about the same time as this new system came in. For those unfamiliar with the term, a well-known example would be Hitler and his Nazis, who tried to wipe out the Jewish population in order to make a more improved Aryan race: the strongest, fastest, smartest humans were bred to create smart, fast, strong, healthy babies. Anyone showing signs of mental retardation, or any other maladies, would not be allowed to procreate. Although this example is the most popular, it was a widely accepted pseudoscience at the time. Darwin's theories were once considered superficially related to eugenics, and Alexander Graham Bell was a big proponent as well; he once conducted a study on Martha's Vineyard regarding deafness and concluded that it was indeed a hereditary affliction.

Feeblemindedness was also considered an affliction passed down through the gene pool, and it was the argument that made many states pass laws allowing for the sterilization of the mentally retarded or disabled. While this debate raged on, Laconia State School was growing from sixty children to eighty-two inmates by 1906. Until this time, mentally disabled children were kept with their families; now, however, they could get rid of their "problem" child simply by bringing them to this fine example of an institution. The three original buildings—the superintendent's home (which also served as dining hall for the kids and an administration office), dormitory and school—had been expanded by 1910 when the new superintendent, Dr. Baker, came in. Several buildings were added to the 250-acre plot: another dormitory so that they could segregate the girls from the boys, a dining hall for the "inmates" and a hospital. In that same year, there were a little more than ninety admissions to the school.

In 1913, the Kallikak study was published by Henry Goddard, director of the research laboratory of the training school at Vineland, New Jersey, for feebleminded boys and girls. It was released under the title of *The Kallikak Family: A Study in the Heredity of Feeble-Mindedness*. The study of this particular family was jump-started when Deborah Kallikak entered Goddard institution. He believed he traced the feeblemindedness back to an affair that one of Deborah's great-great-great-great-great-grandfathers had with a "nameless feebleminded girl." He showed that the children of this nameless woman all ended up with some retardation or disability when compared to that of Deborah's ancestor's lawful marriage, in which there were no such examples. The last chapter of the book asks, "What is to be done?" Goddard

gives a few examples of what he believes will help solve the crisis and what he feels to be the most threatening condition:

No one interested in the progress of civilization can contemplate the facts presented in the previous chapters without having the question arise, Why isn't something done about this? It will be more to the point if we put the question, Why do we not do something about it? We are thus face to face with the problem in a practical way and we ask ourselves the next question, What can we do? For the low-grade idiot, the loathsome unfortunate that may be seen in our institutions, some have proposed the lethal chamber. But humanity is steadily tending away from the possibility of that method, and there is no probability that it will ever be practiced.

But in view of such conditions as are shown in the defective side of the Kallikak family, we begin to realize that the idiot is not our greatest problem. He is indeed loathsome; he is somewhat difficult to take care of; nevertheless, he lives his life and is done. He does not continue the race with a line of children like himself. Because of his very low-grade condition, he never becomes a parent.

It is the moron type that makes for us our great problem. And when we face the question, "What is to be done with them—with such people as make up a large proportion of the bad side of the Kallikak family?" we realize that we have a huge problem.

The career of Martin Kallikak Sr. is a powerful sermon against sowing wild oats. Martin Kallikak did what unfortunately many a young man like him has done before and since, and which, still more unfortunately, society has too often winked at, as being merely a side step in accordance with a natural instinct, bearing no serious results. It is quite possible that Martin Kallikak himself never gave any serious thought to his act, or if he did, it may have been merely to realize that in his youth he had been indiscreet and had done that for which he was sorry. And being sorry he may have thought it was atoned for, as he never suffered from it any serious consequences.

Before considering any other method, the writer would insist that segregation and colonization is not by any means as hopeless a plan as it may seem to those who look only at the immediate increase in the tax rate. If such colonies were provided in sufficient number to take care of all the distinctly feeble-minded cases in the community, they would very largely take the place of our present almshouses and prisons, and they would greatly decrease the number in our insane hospitals. Such colonies would save an annual loss in property and life, due to the action of these irresponsible

people, sufficient to nearly, or quite, offset the expense of the new plant. Besides, if these feeble-minded children were early selected and carefully trained, they would become more or less self-supporting in their institutions, so that the expense of their maintenance would be greatly reduced.

In addition to this, the number would be reduced, in a single generation, from 300,000 (the estimated number in the United States) to 100,000, at least—and probably even lower. (We have found the hereditary factor in 65 percent of cases; while others place it as high as 80 percent.)

The other method proposed of solving the problem is to take away from these people the power of procreation. The earlier method proposed was unsexing, asexualization, as it is sometimes called, or the removing, from the male and female, the necessary organs for procreation. The operation in the female is that of ovariectomy and in the male of castration.

There are two great practical difficulties in the way of carrying out this method on any large scale. The first is the strong opposition to this practice on the part of the public generally. It is regarded as mutilation of the human body and as such is opposed vigorously by many people. And while there is no rational basis for this, nevertheless we have, as practical reformers, to recognize the fact that the average man acts not upon reason, but upon sentiment and feeling; and as long as human sentiment and feeling are opposed to this practice, no amount of reasoning will avail. It may be shown over and over again that many a woman has had the operation of ovariectomy performed in order to improve her physical condition, and that it is just as important to improve the moral condition as the physical. Nevertheless, the argument does not convince, and there remains the opposition as stated.

In recent years surgeons have discovered another method which has many advantages. This is also sometimes incorrectly referred to as asexualization. It is more properly spoken of as sterilization, the distinction being that it does not have any effect on the sex qualities of the man or woman, but does artificially take away the power of procreation by rendering the person sterile. The operation itself is almost as simple in males as having a tooth pulled. In females it is not much more serious. The results are generally permanent and sure. Objection is urged that we do not know the consequences of this action upon the physical, mental, and moral nature of the individual. The claim is made that it is good in all of these. But it must be confessed that we are as yet ignorant of actual facts. It has been tried in many cases; no bad results have been reported, while many good results have been claimed.

A more serious objection to this last method comes from a consideration of the social consequences. What will be the effect upon the community in the spread of debauchery and disease through having within it a group of people who are thus free to gratify their instincts without fear of consequences in the form of children? The indications are that here also the evil consequences are more imaginary than real, since the feeble-minded seldom exercise restraint in any case.

Probably the most serious difficulty to be overcome before the practice of sterilization in any form could come into general use would be the determining of what persons were proper subjects to be operated upon. This difficulty arises from the fact that we are still ignorant of the exact laws of inheritance. Just how mental characteristics are transmitted from parent to child is not yet definitely known. It therefore becomes a serious matter to decide beforehand that such and such a person who has mental defect would certainly transmit the same defect to his offspring and that consequently he ought not to be allowed to have off-spring.

Well, at least now we know where Hitler got his ideas; because of works like this, in order to get married at the time you had to take an IQ test to be sure that neither one of the couple carried qualities of a feeble mind. Some similar examinations were used on Ellis Island and affected immigration law; suddenly Italian doctors were considered "feeble" because they did not know a lick of English and failed their test. Also because of this, New Hampshire, along with thirty-five other states, instituted the first law in 1917 that allowed for the sterilization of "feeble-minded and patients suffering from certain mental diseases, in institutions and at large"; these procedures were called compulsory sterilizations, meaning that they were executed by force.

Dr. Baker, superintendent of the New Hampshire School for Feebleminded Children, had already caught on to the eugenics movement. This was evident in an address he made in 1910 to the board of trustees:

One of the improvements within which I want to call your attention, and which I hope is only the beginning of further research along that line, is the one of making careful hereditary studies of our children, with the view that the public may be shown the results of having in the general community this class of defectives. This work, which has largely been performed by the office assistant, consists of taking some of the most interesting families from which there are, say four in our institution, and then visiting the town from which they came and carefully making a record of as many generations of

that family as possible, the whole later being charted and thus showing the number of feeble-minded, epileptic, insane and criminals. The results are very interesting and will be an object lesson to the public.

As Janet Krumm noted in her article "History of the Laconia State School" from the *New Hampshire Challenge: Disability Issues from a Family Perspective*, did you notice that Dr. Baker said that his office assistant was performing the interviews, diagnosing the members, and that he gives no reason as to why this person is given the responsibility? What are his credentials? Is he a doctor, too? Part of what this office assistant had to do was go back and profile those who had been deceased for many years (because eugenics is all about tracing the feeblemindedness back to its source), so this office assistant was diagnosing people long since dead simply based on what people could remember, which at times was close to nothing.

In 1924, the New Hampshire School for Feebleminded Children was changed to the Laconia State School; from its opening until this point, it had made some of other changes, now allowing women and holding patients over the age of twenty-one all the way up to forty-five. This is an obvious reflection of the belief in the eugenics movement. Between the years of 1925 and 1930, overcrowding at the school became a large issue, and repairs that had been asked for time and again were denied the funding necessary. It was as though the state just wanted to put the ill somewhere and forget they even existed. The dormitories were filled with beds, one right against the other so as to make room; one dorm that had about eighty inmates only had one toilet and a pipe sticking out of the wall for a shower. Some toilets didn't even have toilet seats, and inmates were in a constant state of disarray: some walking around naked and others wearing clothes that did not fit. Most of the inmates were kept medicated so they would not cause trouble; the Laconia State School was on a downward slope under the guidance of Dr. Baker.

Eugenics was still very much entrenched in the care for the feebleminded at the state institution in Concord; various other county almshouses also continued to sterilize their inmates. In 1929, the state created another law, reinforcing its stance on the procedure and solidifying eugenics' place in the Laconia State School history. This one directly concerned inmates of state institutions:

Whenever the superintendent of any state or county institution shall be of the opinion that it is for the best interest of the inmate and society that any inmate of the institution under his care should be sexually sterilized, such superintendent is hereby authorized to cause to be performed by some

capable surgeon the operation of sterilization on any such inmate afflicted with hereditary forms of insanity that are recurrent, idiocy, imbecility, feeble-mindedness or epilepsy.

World War I had begun, and the funding shortages were even more severe; at this point, the mindset was on containment. In 1940, there were about 640 inmates living at the school, and the focus was not so much on actual education as the name might imply; therapy and medication became the mainstays, and for those inmates who stepped out of line, well, they could expect severe punishments.

By 1950, sterilization and eugenics became unfashionable to most in the medical community. One of the largest institutions in the state was the New Hampshire State Hospital in Concord. Superintendent Donald Niswander, MD, commented on the fading fad: "I believe that this reduction in operations over the years, with the changes in the hospital administration, likewise there have been changes in the philosophy regarding the sterilization of the mentally ill…if relatives request sterilization they urge to take the matter with their family doctor." During this time, people also began to realize that mental retardation was not just an illness given through a family line but also one born out of the person's environment.

Robert Hungerford, a teacher and future superintendent of Laconia, had ideas about reform. In 1952, he took on the mantle and decided that it was time to change some things. Firstly, he decided to open the doors of Laconia State School to the parents, realizing the intrinsic political heft that these people would have. What the parents saw astounded them—they equated the school with concentration camps over in Germany. They were soon forming groups across the state to gather more funding for the school in 1953; under the advisement of the school's superintendent, parents formed the New Hampshire Council for Retarded Children. These parents and citizens lobbied and advocated their way to more funding, better conditions and more understanding for the residents at the Laconia State School. They also created summer workshops for public school teachers, showing them how to educate the mentally retarded, and a bill passed that allowed for those with mental impairments to be taught in public schools under the term of "handicap" that until this time meant only those with physical handicaps. Unfortunately, when the bill passed, it allowed for the education of the mentally disabled period; it did not indicate that these children could go to public schools.

While under Hungerford, the school went through other massive changes besides just that of philosophy; with the help of the parents' group and new

The Poor and the Mentally Ill

The Spaulding Building.

funding, he created two other cottages, which had a more home-like feel to them, with curtains on the windows and two or three people in one room. He also instituted mixed-sex education—which up until that point had not been allowed; girls were kept strictly separate from the boys on the belief that the mentally retarded could not control themselves. Parents were deeply fond of Hungerford; however, as time went on, the government grew to resent him wanting more money and more understanding than the mindset at the time believed the feebleminded were worth. To the average middle-class citizen at the time, feeblemindedness was worse than a second-class citizen, and they deserved no true help. Edna St. John wrote about it:

When [Richard Hungerford] *came to New Hampshire in 1953 he was hailed with hosannas. Then, as his total professional and moral commitment to the retarded came to be understood, he was looked upon with wariness, and finally and tragically with hostility. In the main, New Hampshire's bureaucracy felt no moral commitment whatsoever to the retarded and from now on it was going to keep a close rein on its financial commitment. The accolades had turned to venomous criticism.*

The parents circulated a petition to help Hungerford keep his position; unfortunately, it was too late. He resigned in 1960. His successor was yet another educator named Arthur Toll. His ideas were along the same line as Hungerford's; however, after witnessing what happened to his predecessor, he decided not to go to the extreme. The focus continued to be on education; however, there were still many inmates kept on heavy medication, and television sets were in almost every common room.

By 1961, there was no longer a board of trustees. The power was squarely in the hands of the department of health and welfare and that of the superintendent. Also, a work incentive program had been established, as the dairy and agricultural farming that had once been on the property was removed. This showed that the state school was no longer interested in creating a self-sufficient community within the school so that the public could be kept safe. By 1974, there were one thousand patients and four hundred still on a waiting list. In 1975, New Hampshire passed RSA 171-A ("the Division of Mental Health to establish, maintain, implement and coordinate a comprehensive service delivery system for developmentally disabled persons"). This law implemented a state agency to outline eligibility requirements and deemed that each disabled person was to be treated in ways considered to be humane, that they were guaranteed hospitable living environments and much more: "Each developmentally disabled client has the right to adequate and humane habilitation and treatment including such psychological, medical, vocational, social, educational or rehabilitative services as his condition requires to bring about an improvement within the limits of modern knowledge." This affected Laconia State School, as well as other surrounding institutions.

Even with the rise in funding from the Developmental Disabilities Act, which had passed one year earlier, Laconia was still not up to par. On the heels of this new law, Laconia invited Michael Dillon, a superintendent for Central Connecticut Regional Care, to come view the school and give opinions on improvements that could be made. At the end of his report were his notes: "In the end, however, while federal funds may lighten the cost, the state of New Hampshire must consider what it will provide to its handicapped citizens. Will it tolerate its citizens to live in a barren, sterile environment, devoid of stimulation? Will it seek to find a better, more humane way of providing for them?...The issue then is apparent. What needs to be done is known. That it is costly is true. Who will take the initiative?" He simply says this because, yet again, while during a walkthrough, he noticed the lack of clothing, shoes and care that the patients received. They had the

The Blood Building, used as a dormitory for residents.

bare minimum when it came to health standards, and educationally it was appalling to see that their programs left much to be desired in terms of planning and frequency.

During that same time, Jack Melton became the new superintendent, and the advocacy groups and parents put more pressure on him to change things, so he complied. During his time, he instituted the Intermediate Care Facility for People with Mental Retardation funding system, cleaned up the area and implemented several new educational programs. He also increased the numbers of trained staff who worked within the institutions walls, bringing in more professionals who specialized in different areas such as occupational therapists, physical therapists and speech therapists.

Despite so much work on the part of Mr. Melton, the conditions did not seem to improve enough. On April 12, 1978, the parents of those residing at the Laconia School (there were 1,100 patients at this time) filed a class action lawsuit against the state, saying that it had broken its own newly inducted law and that it also broke the Eighth and Fourteenth Amendments of the Constitution. The Eighth Amendment speaks on cruel and unusual

punishments while the Fourteenth Amendment, Section One, states: "All persons born or naturalized in the United States and subject to the jurisdiction thereof, are citizens of the United States and of the State wherein they reside. No State shall make or enforce any law which shall abridge the privileges or immunities of citizens of the United States; nor shall any State deprive any person of life, liberty, or property, without due process of law; nor deny to any person within its jurisdiction the equal protection of the laws."

During this very public trial, which garnered media attention, the focus was not just on the injustices that these poor souls had to endure at the hands of an oblivious government but also on the idea of institutions altogether. The trial became a clash between two different mentalities: those who believed in community building and those who believed in segregation. TASH (Association of the Severely Handicap), which had never been involved in an institution's case, did get involved in this one. Its mindset was strictly based on the idea of integrating the mentally handicapped with the community. One of the plaintiff's lawyers, who had a meeting with the TASH leaders, reported one of them saying, "I won't help if you want to fix up the institution. If you want to close it, I'll put you in touch with every expert you'll need."

The trial itself became the longest civil trial ever enacted in the Granite State; at the end of it, the judge gave a ruling that brought peace to both parties, as one official was quoted saying:

The judge cut the baby in half perfectly. It was a Solomon like decision. The judge ordered us to plan. So that the plaintiffs won; but we won... So that the state gets to implement the way it wants to implement provided that it delivers on what the plaintiff outcome is...the state couldn't say it wouldn't go forward because it was being ordered to do what it wanted to do, and...the plaintiffs couldn't say they didn't want the state to go forward because the judge told them they won...so it was a very cohesive concept of a court order.

By 1991, Laconia State School had closed; for all of the evil and injustice that had happened there, it brought about great change within the Granite State's laws, as well as education and attention from the public. The buildings at LSS did not go without purpose, although many of the structures were too hazardous to reopen; that same year, the Lakes Region Facility took its place. The LRF housed minimum- to medium-security inmates and continued operations until June 30, 2009.

Behind barbed wire, the school becomes a prison.

The entrance to the morgue. *Courtesy of Chris Gentry.*

Chris investigating the morgue. *Courtesy of Chris Gentry.*

The stairwell where Chris saw a woman's face come at him. *Courtesy of Chris Gentry.*

I (Katie) worked at LRF for a short period of time when I first came out of the academy. It was always very creepy to me; there were buildings that were completely off-limits. Now, a conspiracy theorist might say that they are hiding something. In part this is true; they are hiding their past in those abandoned buildings, but it was also a matter of safety.

Unfortunately, I never got the chance to explore the facilities with Beckah in any investigative endeavor. However, a good friend of mine, Chris Gentry, did. Chris was part of a paranormal group at the time, and they had become friends with the wife of one of the staff. Her husband reported that there had always been spooky things going on in there: hearing children laughing or feeling as though you are not alone.

While Chris was there, he not only got to go into some of the restricted areas, such as the chapel and parts of the orphanage, but he also had an encounter with a spirit. While walking up one of the stairwells, he saw the face of a woman come out of a wall at him.

He was not allowed to go into some of the buildings, as they were not safe. However, he did get to go into the morgue and check out where the bodies used to be kept. Less than a month after having investigated the buildings, one of the massive restaurant-grade refrigerators actually fell through the floor.

How to Get There

Unfortunately, access to the now closed Laconia State Prison is not available to the general public, so we will not be including directions for this one.

INTERVIEW WITH A
GHOST HUNTER

*S*hannon Sylvia is more than just the cute girl who got lucky and ended up on Ghost Hunters International's first season. She is a wife, a dog lover and an astute businessperson. She considers the paranormal to be a hobby that she pursues with great enthusiasm. From her first appearance on Paranormal State to her last filming on Ghost Hunters International, Shannon has felt blessed by her experiences. Life after the hit ghost hunting series was not all riches and fame. Shannon maintains that she has worked hard to keep her reputation at its best and continues to be active in the paranormal community. She is an inventor, a skeptic, an Internet star on her show Shantown plus on her husband Jeff's show Up for Discussion and an event coordinator for her company Para Rock Productions. But that is just the paranormal stuff; she also runs a successful graphic and web design studio called By Design, where she offers business cards, posters and other media, as well as, of course, websites. We got the opportunity to sit down with this "para-celeb" to talk about her life, her career, her methodologies and more.

Q: What first got you involved or interested in ghost hunting?
A: When I was born [laughs]. I was a toddler when a lot of paranormal activity was happening in my home. My mother contacted a local priest. We were working with the Catholic church here in town as far as getting people to come to the house and pray and try to bless the house continuously throughout the years by different priests. My mother said we had our first paranormal experience when I was three years regarding something that happened with one of my stuffed animals; it made a bad face at me. Now I was also having seizures at that age, and I was on medications for that, so I went through all of the tests. I did grow out of that after about a year. But

Shannon gives a lecture on different types of photographic anomalies and how to debunk them.

things in the house continued, and growing up I just remember constantly having footsteps coming up the stairs and things moving and hearing voices. I always thought that was normal. I realized as I got older that it wasn't normal because nobody else was talking about it or having it done on them. I used to save my allowance, and I was buying books from Raymond Moody [and] Hans Holzer and studying everything from out-of-body experiences to ghosts. So I was always interested in the paranormal for as long as I can remember. I always loved watching shows on TV about it.

In high school, I sorta put it on the back burner. I was a cheerleader. I was trying to fit in. I didn't want to talk a lot about that stuff, but my friends coming over knew something was going on with the house. In college, again, I focused on my studies, but a lot of things were happening in the house around that time. I finally left that house and moved into the one I'm in now. And paranormal activity started again. I couldn't believe it. I actually thought that whatever was at my house growing up came with me. But I realized soon after that the activity was different. It was lighter. It was a lot of things moving around. It didn't feel as heavy or scary as the things that were happening in the other house.

Back in 2000, my mother moved out of the old house and built one the next street over. There hasn't been any paranormal activity in the new house. There has been a high turnover of families that are in the house that I grew up in. My sister has been a babysitter for several of the families because she lived so close. She would actually return to our old house and watch the kids over and over and over. Eerie, but never reported anything weird happening after I left there. After I left, the activity in the house subsided. My mother and my sister never complained of anything happening there.

Q: After you moved to where you are currently living, you ended up calling in a paranormal team and later joining their group. Part of what you had to do was attend a Paranormal 101 [class]. Did you find it helpful to you?

A: The course was only two hours, and as you know, in two hours you can't cover everything you need to. The first hour was basically technique and etiquette; the second hour, it got into the darker stuff. That is where I met Keith and Sandra Johnson, and they did some videos which they still show to this day [of] actual exorcisms and demonic hauntings and paranormal evidence, which looked pretty convincing to me at the time. I don't think they expect to hand everybody a certificate after these courses. It was definitely an educational course, because I got to see and hear things I had never seen and heard before. I mean if you're brand new to this, it wouldn't hurt, but don't spend a ton of money on them either. People charging a hundred bucks, seventy-five bucks, it's not worth it. Back then, in 2005, when there was nothing to watch on television except for one ghost show, it gave me the opportunity to ask questions in the class that you couldn't ask the television set.

Q: We've talked before about how it takes a certain type of person to be a demonologist; do you think the same applies to paranormal investigators? Have you noticed any common denominators with those who do well in the field?

A: Uhm. Honestly I can say in meeting all of the people that I've met there are many different personalities. But I do see that the ones that want to learn do the best. The ones that sit and pay attention, the ones that aren't there to play show and tell. It's usually the quieter ones that usually have some background in police work, investigations work, or medical field, where they have a pretty decent education, and they are there to learn and absorb and actually concentrate and pay attention. There are the workhorses and the

show horses, I enjoy working with the workhorses a little bit more, but yeah I'm still learning every day myself you can't learn by fooling around and showing off, acting like you know everything. You can't go to investigations and debate everything. Just go in, learn and do your job. I enjoy the very few people who are still learning and who still have that thirst for knowledge.

Q: While you were on Ghost Hunters International, what was the scariest place you have been?
A: Lucedio Abbey in Torino, Italy; coming from a Catholic background, hearing that we were going to investigate a monastery built in 1100, was really neat to me. Three hundred Catholic monks lived there; according to the Internet and records, something happened in that monastery where some women came onto the property of nothing but men. To make a long story short, they converted all of the men to Satanism. They started doing brutal acts of murder, kidnapping, rape, abuse and torture. It just went haywire until the pope came in and decommissioned the monastery and no longer made it a sacred place or a valid church. It seems like a wacky story. I don't know how much validity was in it. Napoleon, they all raided the property at one point and took the property over as their own, then traded it back to the Italians for something else.

When you pull into the property, there was an aura about that place that I never felt in many of the other locations we've visited. Especially at dawn, it was so quiet and serene, but that didn't bother you as much as the feeling that you had [that] I never really could quite explain, but you could tell there was something there and it was big. The boys were complaining that it was a quiet night for them, but the two girls, we had experiences. We had entered the church, and we heard a disembodied voice say "basta" which means "enough" in Italian, and they heard it. But I think that was it for the boys. But I felt like I was constantly being watched in every inch of that place. There was a large spiral staircase; one of the crew stayed on the basement, another in the middle level and I stayed up at the top. The top level really bothered me because there were a lot of drawings with crayons on the walls—very old. So you could tell there was some kind of school there at some point. It wasn't graffiti; you could tell it was deliberately done over a period of time. These rooms had fireplaces in them. They were like boarding rooms for a school. But I forget the exact history. I was standing on that floor. I didn't want to stand at the top of the staircase, because I felt like I was going to get pushed. So I sat and sorta held onto the railing. I felt...and I'll never forget it...like a light touch on my right arm. It was very

buggy. The mosquitoes out there were the size of cantaloupes...Trust me. I kept feeling something on my right arm, so I started thinking, "Is there a draft in here?" because I'm sitting at the top of a stairwell. So I called down to one of the other members, "Are there bugs in here?" and he said, "No Shannon." Then I clearly felt a touch. I started freezing and panicking, and I started getting numb, my fingertips, my feet, my lips. I was just terrified. If that had happened now, five years later, I would've had a thicker skin. But back then I was just terrified.

There were a few other things that happened, but that place terrified me. Myself and three boys from the cast were in the chapel where we had heard that voice before. The chapel was in the shape of a cross, so everyone took a corner, and I was at the top of the cross, so basically I was facing everyone else. It was pitch-black—no electricity on the whole property. Thirty thousand acres of rice, you got nothin' for light. I was standing there. We were doing an EVP session, and I felt something standing next to me on my right, and I knew it. I just knew, can't explain it. So I shuffled away. Finally, someone said, "Shannon, are you moving?" and I said, "Yes." And they said, "Why? Because you didn't acknowledge it." And I said, "Well, I was hoping it was quiet enough that you didn't hear me. I just needed to move." Right after we finished, Barry said to me, "Shannon why did you move? It's because someone was standing next to you, wasn't it?" and I said, "How do you know?" And he said, "Because I saw it." He said it was huge, it was absolutely enormous, standing next to me. I was just so upset that he didn't say it when he saw it. He said it was a man with very wide shoulders and very tall. It was really interesting.

Q: You created the I-Way, a Ouija board planchette that actually measures finger pressure, allowing for a foolproof way to see if spirits are really moving it or if it is whomever you are using it with. Can you tell us a little bit about it?

A: I'm absolutely fascinated with the Ouija board. A lot of study needs to be done with the Ouija board. Thanks to Beckah. She's the one who prompted me to do the research on that. Mitch Silverstein, an engineer from Nyack Paranormal, I contacted him one day about the idea. I asked him if he could put together these elements so we could create a planchette that would actually measure people's finger pressure, so that we could debunk whether or not somebody was pushing that planchette. Within one day, he had the prototype, and I got it just two days later. We called it the I-Way, because it does weigh. It's like a scale.

Beckah and Shannon using the I-Way planchette.

We took the prototype to an event in North Carolina where there were a lot of people present, and I chose a bunch of skeptics out of the crowd. People that had never used a Ouija board before because they simply didn't believe that it worked. So I sat these five people down, along with many witnesses that there were at the event, and we turned the planchette on. Somebody had actually gone out and bought a Ouija board for us. Within a few minutes, the planchette was moving underneath their fingers, and I will never forget that moment. I shed a tear when it was moving, and it was surprising the people using the planchette quite a bit. It was spelling out messages. It was a little girl who was six years old who died. The planchette showed us that while it was in motion the baseline reading of the finger pressure was actually less than when it was standing still with the same number of fingers on it.

The whole point of it is that you take a reading before a session, no matter how many fingers you have on it. You just tell people to simply put as little pressure as you can on the planchette. You do get a ballpark as to what that pressure should be collaboratively and when the planchette was moving that very first day that we tried to experiment with it. That baseline reading that

we got was less when it was moving than it was when standing still, which means that it had some sort of help moving around other than human finger pressure, which to this day I can't explain why or how. But if somebody was to be pushing that planchette or pulling it in order to form a word or move it in the direction of a letter, the scale on the I-way would've weighed that finger pressure, and it would've put those numbers right there on the screen in front of the people.

This was not the first piece of equipment that Shannon had invented; she also adapted a green laser for use in the paranormal field under the theory that ghostly mass would break up a laser beam whereas humans will not. She found a head for a simple laser pointer that broke up the beam into a grid pattern. It was intended for her own research so that she could shine this laser down a hallway, creating a grid across the entire area. She found out that it was fun to look at and that it was very easy to detect the phenomena known as shadow figures when they pass through it. A lot of teams at the time had been using laser pointers, but they were a single-lined laser, not a grid. Shannon wanted to be able to catch a whole body of a spirit instead of just one part.

She first used it at Fort Mifflin and it worked! Immediately, one of the girls there wanted the laser; she offered to pay whatever Shannon had paid for it. So Shannon sold it and bought another. Now you will find Shannon's laser on television shows such as Ghost Adventures *and* Ghost Hunters; *teams across the country are praising the laser as a simple but brilliant piece of investigative equipment.*

You can learn more about Shannon's inventions, adaptations, seminars, conferences and more at www.shannonsylvia.com.

RESOURCES

Here are several different resources and places where Katie and I like to hang out on the web and do research or that we believe are important to the book and discovering New Hampshire and its neighboring states' hidden haunts.

RADIO SHOWS AND STATIONS

Ghost Quest Radio
www.ghostquest.org
www.tenacityradio.com

The Morning Show with Parker and James
K-Rock 101.9 FM, Keene, New Hampshire
www.keenerocks.com

The Psychic Switch
www.thepsychicswitch.com
www.tenacityradio.com

PTN
www.peoplestvnetwork.com
Be sure to check out Sylvia's shows:
Up for Discussion and *Shantown.*

Shadows in the Dark
www.sitdradio.com

RESEARCH

Gen Disasters. www3.gendisasters.com. Great resource for finding news clippings related to disasters of yesteryear.

Ghost Towns. http://www.ghosttowns.com. Check out different ghost towns in your area.

New Hampshire State Archives. www.sos.nh.gov/archives.

WEBSITES

Beckah Boyd Psychic Consultation. www.ancientwisdomnh.com/bhome. html.

Ghost Quest Paranormal Research Society. www.ghostquest.org.

Katie Boyd. www.katieboyd.net.

Lake Winnipesaukee Website. www.winnipesaukee.com. A great website for all things about the lake and surrounding area.

Mysteries magazine. www.mysteriesmagazine.com. Got to love this magazine, chock-full of the strange and unusual.

New Hampshire's guide to restaurants, lodging and activities. www.nh.com.

New Hampshire Travel. www.nhtourguide.com. Every once in a while, the site includes a paranormal investigation. Otherwise, it's a really good site for finding fun and historical places to check out around the Granite State.

Planet Paranormal. www.planetparanormal.com. Bob Davis runs this site dedicated to all things paranormal.

Shannon Sylvia, the official website. www.shannonsylvia.com.

Supernatural Hotspots. A side project we've been working on. www.supernaturalhotspots.com.

BIBLIOGRAPHY

"Adomnán." *Life of Saint Columba, Founder of Hy.* Edited by William Reeves. Edinburgh, Scotland: Edmonston and Douglas, 1874.

B., Kathy. New Hampshire UFO Archives. www.nhufo.org/nh%20ufo_archives.html.

Boyd, Alistair, and David Martin. *Nessie: The Surgeon's Photograph EXPOSED.* N.p.: Book for Dillons Only, May 1999.

Coleman, Loren. "Water Horse, Nessie, and Sex." Cryptomundo, December 15, 2007. www.cryptomundo.com/cryptozoo-news/nesssex.

DeLange, George, and Audrey DeLange. "Loch Ness and Nessie." DeLange Homepage, December 2009. http://www.delange.org/LochNess/page9.htm. Travel and tour pictures, photos and information.

Fosters Daily Democrat. "Great Conflagration in Dover." January 26, 1907.

———. "Last Body Identified." January 28, 1907.

Gallagher, Nancy L. *Breeding Better Vermonters: The Eugenics Project in the Green Mountain State.* Hanover, VT: University Press of New England, 1999.

Hamilton, David, ed. *History of Merrimack and Belknap Counties, New Hampshire.* Philadelphia: J.W. Lewis & Co., 1885.

Hill, M. Constance. *Mary Russell Mitford and Her Surroundings.* Illustrated by G. Hill. London: Bodley Head, 1920.

Krumm, Janet M. "The History of the Laconia State School." *New Hampshire Challenge* 7, no. 1, 1994, 1–8.

Krystek, Lee. "Nessie of Loch Ness." The UnMuseum. 1996–2007. www.unmuseum.org/lochness.htm.

Lawhon, Loy. "The Hill Abduction." About.com, July 29, 1997.

Lee, Heather. *His Name is Bob: A Documentary Film: Valley of Darkness*. 3Frog Productions, 2007.

Lorren, Brooke. "The Story of Mary Anning, Shell Seller and Paleontologist." *Associated Content*, February 16, 2009. http://www.associatedcontent.com/article/1453430/the_story_of_mary_anning_shell_seller.html?cat=38.

Manchester Leader and Evening Union. "Bear on Ice Cake, Two Leopards Cling to Menagerie Roof." March 20, 1936.

———. "Heroic Police, Volunteers Save 32 From Death in Piscataquog." March 20, 1936.

Marsh, Robert. "UFO picks up Laconia, NH car with teens and drops 180 feet away." Examiner.com. www.examiner.com/x-2363-UFO-Examiner~y2010m4d18-UFO-picks-up-Laconia-NH-car-with-teens-and-drops-180-feet-away.

New Hampshire Challenge. "Petition by the NH Federation of Women's Clubs." August 2004.

Open Lands Committee. County Farm Cocheco Loop Trail and Winning Ways Stables. Dover, NH: Open Lands Committee, 2008.

Paul, Julius. *State Eugenic Sterilization Laws in American Thought and Practice: New Hampshire*. Washington D.C.: Walter Reed Army Institute of Research, 1965.

Racino, Julie. "*Garrity v. Gallen*: The Role of the Court in Institutional Closure." *Community and Policy Studies* (1993): 17–23.

Rood, Jeremiah. "Factory on Fire! Kicks off Friday." *Fosters Daily Democrat*, May 2006.

Scales, John. *History of Strafford County New Hampshire and Representative Citizens*. Chicago: Richmond-Arnold Publishing, 1914.

Scotland Inverness and Loch Ness Map. 2006–2010. http://www.visitlochness.com/maps/loch-ness-map.php.

Stone, Simon. "Sexual Sterilization in New Hampshire." *New England Journal of Medicine* 215, no. 12 (1936): 536–46.

ABOUT THE AUTHORS

Beckah Boyd is a sixth-generation psychic medium with more than fifteen years of experience and practice. Beckah not only speaks, hears and sees loved ones who have passed but can also see into the past, present and future. She has worked with energy in multiple modalities since she was thirteen. More than ten

Katie Boyd and Beckah Boyd.

years ago, she cofounded a paranormal group called Ghost Quest. Since then, she has gained a reputation as the "skeptical psychic" when it comes to her investigation methods. Beckah is the coauthor of *Ghost Quest in New Hampshire*, which is about her paranormal group's first two years of cases. In addition, she is the author of the book *Raising Indigo, Crystal and Psychic Kids*. Beckah is also host of the radio show *The Psychic Switch* and co-host of *Ghost Quest Radio* on the Tenacity Radio Network.

Katie Boyd is an internationally known demonologist and occult sciences/crimes specialist residing in New Hampshire. She grew up in a haunted house, which had severe poltergeist activity that had tore her family apart,

and now helps those who are dealing with similar issues. Katie is considered an expert in her fields and has more than twenty-one years' experience in studying and training. She handles all types of cases, from everyday spirit hauntings to demonic entities, demonic haunting, exorcisms, possessions and occult crime cases from around the world. Katie has written many books, including *Ghost Quest in New Hampshire*, *Devils & Demonology in the 21st Century*, *Rhode Island's Spooky Ghosts & Creepy Legends*, *Haunted Closets: True Tales of the Boogeyman* and *Witches & Witchcraft in the 21st Century*.